EMPIRE

EMPIRE

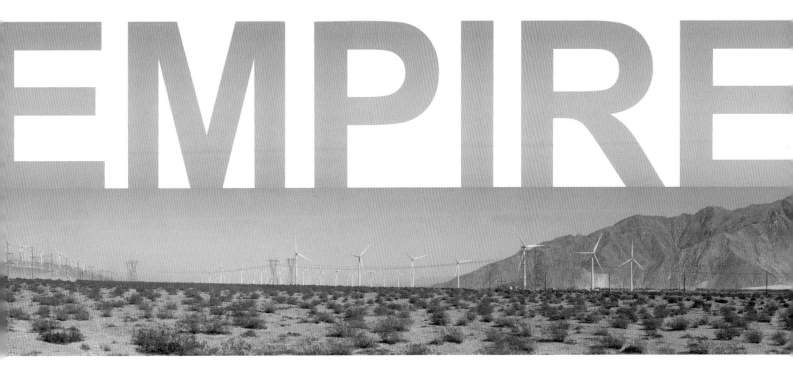

PHOTOGRAPHS AND ESSAYS BY LEWIS deSOTO

FOREWORD BY PAUL CHAAT SMITH

HEYDAY, BERKELEY, CALIFORNIA

INLANDIA INSTITUTE, RIVERSIDE, CALIFORNIA

ROBERT AND FRANCES FULLERTON MUSEUM OF ART,
CALIFORNIA STATE UNIVERSITY, SAN BERNARDINO

Library of Congress Cataloging-in-Publication Data

DeSoto, Lewis, 1954-
 Empire / photographs and essays by Lewis deSoto ; foreword by Paul Chaat Smith.
 pages cm
 "Inlandia Institute, Riverside, California; Robert and Frances Fullerton Museum of Art,
California State University, San Bernardino."
 ISBN 978-1-59714-334-9 (paperback : alkaline paper)
 1. Inland Empire (Calif.)--Pictorial works. 2. California, Southern--Pictorial works. 3. Riv-
erside County (Calif.)--Pictorial works. 4. San Bernardino County (Calif.)--Pictorial works.
5. Inland Empire (Calif.)--Description and travel. 6. Inland Empire (Calif.)--History, Local. I.
Inlandia Institute. II. Robert and Frances Fullerton Museum of Art (San Bernardino, Calif.)
III. Title.
 F867.D47 2016
 979.4'90222--dc23
 2015020308

Front Cover Photo: Whitewater, June 2013
Back Cover Photo: Salton Sea Beach, January 2014
Book Design: Ashley Ingram

Orders, inquiries, and correspondence should be addressed to:
 Heyday
 P.O. Box 9145, Berkeley, CA 94709
 (510) 549-3564, Fax (510) 549-1889
 www.heydaybooks.com
Printed in China by Print Plus Limited

10 9 8 7 6 5 4 3 2 1

CONTENTS

FOREWORD

INVISIBLE INSIDER

One of the biggest problems the people of Earth face is California.

For if California is golden, it must follow that everyone else is not. California showers the planet with dreams and entertainment, and although much of it is awful and soul-crushing, some is brilliant and life-affirming (says me, the person still mourning the end of *Breaking Bad*—both soul-crushing and brilliant—which was originally set in the Inland Empire, a detail that has nothing and yet everything to do with this book).

California: we can't live with you or without you. But what is to be done? What new can be said? Now, apparently, on top of simply being annoying, the state is also running out of water, although LA looked pretty damn lush when I was out there a few months ago. California is in our heads, all the time. How did that happen? Because, I guess, it's the richest state in the richest country in the history of the world. So it goes wherever it wants.

Can artists solve this problem? No, but they can make art about it.

When I heard that Lewis deSoto was publishing a book of photographs, I thought, "Cool!" When I heard Lewis deSoto essays were accompanying the Lewis deSoto photographs, I thought, "Not cool!" Why? Well, I don't think artists should write. We have enough writers! Artists should make art, and leave the writing to writers, and vice versa. God knows it's hard enough to do either one passably well. Especially writing, which is really, really hard. Plus, it has rules, whereas with art you can just kind of make it up. Anything goes. Nothing is absolute, so sure, there are people who successfully (and arrogantly) defy these obvious and reasonable guidelines. But even if I'm forced to concede some pretty good painter can also play a mean jazz piano, I still don't have to like him, or it, or whatever. Maybe this phenomenon exists, but is it a good thing? No. Stay in your lane, people!

However, it turns out the deSoto essays are nearly as good as the deSoto photographs. Some might say they are *as* good, or that they are even better, but no way I'm going that far, for reasons explained above. Anyway, what we agree on is that the words change the images, and the images change the words. Yes, like a Hollywood romantic comedy, they complete each other!

Except *EMPIRE* is not that kind of movie, if it even was a movie, which it isn't.

I can't decide if Lewis deSoto is allergic to cliché or simply not interested, or if somehow he doesn't even see it, which seems especially difficult when the subject matter is California. Yet this freshness has long been present in his art projects, which never quite go where you expect and yet somehow feel as if the decision to go elsewhere has nothing to do with our expectations. How do you, for instance, author a book of photographs and essays about the Golden State and never use the words Golden State or Manifest Destiny or Ishi? How do you argue that Palm Springs is the center of the world but ignore the Rat Pack and JFK and Marilyn Monroe? And make it look like you're not just ignoring them to make a point? (Lewis! So much low-hanging fruit, just there for the taking!)

Well, you do that with enviable sentences like this, brisk as mountain air: "First came the Spanish (who named it), then the Mormons, who were tricked into the middle of turf wars between opposing indigenous groups. Next came the new Americans, who swept in like waves of difference—Spanish, Mexican, Irish, German, Japanese, Chinese, African American, and then the refugees that blew like dust from Texas, Oklahoma, and Kansas during the Depression. We Cahuilla watched it happen all around us. We were the invisible insiders."

Beginner's luck? The exception that proves the rule? Not. Sure. What. To. Think.

Anyway, if you're looking for exhausted narr-atives and movie stars, keep moving. But if you're looking for a different California—one with lots of cars and lots of roads, plus smoke trees, the world-famous Wigwam Motel, and the dull hum of desert factories and distant rumble of B-52s loaded with atomic bombs—read on. In some cases, this California is delivered via perfect sentences; other times it comes in the form of perfect photographs.

Either way, what is here is unforgettable.

Paul Chaat Smith
Washington, DC
June 2015

CURATOR'S STATEMENT

BY SANT KHALSA

Lewis deSoto has come home to create *EMPIRE*. He returns to rediscover the place where he came of age as an artist and to uncover personal memories and cultural history deeply rooted in the land of his ancestry. It was here in the Inland Empire that deSoto learned to see, and here he developed an individual, complex, and mature visual language that manifests in his extraordinary photographs and installation works.

His art practice is a meditation on remaining present in time and place while uncovering memories of past experience, with sensitivity to the histories demarcated in the land. The beauty of nature and human experience as reflected in the landscape has long been the inspiration for deSoto's work. His photographic and site-specific installations resonate with the idea of *shibui*, the Japanese term for art that is not deliberately designed and produced as a product but rather arises from the simplicity, silence, naturalness, and imperfection found in daily living.

From 1989 through 2007, deSoto moved beyond his photography practice to focus on the more process- and time-based aspects of his work, establishing himself as an installation artist. He was an innovator in shaping this medium as a way to express the nuances of various social histories and worldwide cosmologies through personal vision and practice. His site-specific works integrate sound, light, video, space, and sculptural and performative elements to create multilayered environmental and sensory experiences. This new direction gave him freedom to wander in fresh terrains of research and conceptual inquiry while remaining grounded in storytelling infused with poetic metaphors and symbolism.

Lewis deSoto returned to photography as the evolution of digital image-making technology presented new and creative methodologies with which he could translate his conceptual ideas about place and sensory experience. With these new tools and technologies he was able to make photographic images that reflected his early photography and aligned with the ideas, vision, and philosophy developed in his installation works.

He returned to photographing in Napa, California, where he has lived since 2000. Noting that this viticultural environment was reminiscent of the agrarian landscape from his childhood, his vivid memories of home inspired him to visit and revisit the Inland Empire to explore, reminisce, and photograph. It is with a renewed passion to document his experience that he returned to the sites where his voice and vision as an artist were established. His photographs often suggest the landscapes of his recollections, but the vineyards and orchards themselves are rarely seen, having been replaced by big-box stores, warehouses, and parking lots. His new images depict the acute awareness that the Inland Empire is a mutating environment, altered by the constant change of people and cultures, cars and structures, agriculture and industry, as well as natural events including floods, fires, and earthquakes. The grandeur of the snow-capped mountains and the spacious desert land and skies still dominate, albeit marked with evidence of the past and a changing present.

DeSoto is a master craftsperson, and his meticulous use of particular processes and techniques is one of the signature qualities of his work. He is precise in his construction of composition and meaning, and the way that message signifies his understanding and experience of place and being. In *EMPIRE*, deSoto creates photographs using two distinct processes. The variation in his stylistic approach to the panoramas versus the single-frame images is a conscious attempt to envision and evoke different experiences of place.

The panorama photographs in *EMPIRE* reject the limits of single-frame composition. These expansive landscapes are made from fifty to two hundred handheld photographs merged together in a digital processing program, a method deSoto employs for extending time to construct an interpreted view of his experience as well as to create images with uncanny detail and verisimilitude. The process, grounded in objective observation, is spontaneous yet systematic, spiritual yet technological, an artistic practice linked to the notion of seeing, recording, and translating. In this technique, deSoto has discovered for himself a means of translating

the concepts inherent in his installation works into the photographic realm, such that his two-dimensional work also reflects his perspective and perception, echoing his way of seeing and being. DeSoto's practice fuses reality, time, and meaning. The resulting artwork is evidence of his action— the event of contemplation and remembering —and through his panoramic images we share his totality of experience, his meditation on the transitory notion of place and time. The scale of these panoramas as exhibited engulfs us in the scene and allows us to stand where he stood and see as he sees the complexity of our human environment. We are sited with deSoto in the landscape, bearing witness, standing still, in an extended moment.

In contrast to the panoramic landscape images, the single-frame photographs are suggestive of the "New Topographics" approach to illustrating the intersection of natural and built environments, both their conflict and harmonious juxtaposition. Additionally, a number of these works were made with a "rephotographic" strategy —that is, deSoto returned to specific sites to stand in the locations where he had made his first Empire photographs in 1979. The influence of the New Topographics photographers is evident in both his early and current Empire photographs. In deSoto's single-frame images we observe the color sensitivity of Stephen Shore, the tenor of Joe Deal (deSoto's former professor at UC Riverside), and the minimalist-style aesthetic of Lewis Baltz. We may read deSoto's images as documents because of his pristine objectivity and conscious formalism, yet the images are haunted with intangible ghosts of the past—both the ghosts of his own memories and the ghosts of others who have inhabited the land.

■ ■ ■

In *EMPIRE*, deSoto has also found a new means of expression through words. His narrative essays and extended captions add an intimate and poetic voice to his stunning images. We are privileged with his personal point of view and stories, which give us a fuller understanding of the artist's

experience of the sites he photographs. His writing expands the time signature of the photos and brings greater focus to the memory of place and history.

Lewis deSoto's work reminds us that time is elusive and memories are fragmented realities that are continually changing with our evolving perception and perspectives. We experience place through his eyes, mind, heart, and spirit, and we stand with him as witness to this transcendental life.

This book presents a comprehensive look at Lewis deSoto's Inland Empire project, featuring both single-frame and panorama images, reduced in scale. The exhibition at the Robert and Francis Fullerton Museum of Art (RAFFMA) on the campus of California State University, San Bernardino, from November 2015 to February 2016 featured deSoto's large-scale panoramas alone.

INTRODUCTION
ETERNAL RETURN TO THE LAND OF GHOSTS

I was born in San Bernardino and spent my childhood there. My adult life began in Riverside, and I fluttered between those two worlds for many years until I moved to Washington State when I was thirty-one. Growing up, my consciousness was punctuated by the landscape, especially how it looked passing through a windshield. Cars were my window to the world, and it was glorious. This place was called the Inland Empire, and despite its name it was free of singular leaders or tyrants. It was an empire of things. Oranges, tract homes, steel, freeways, earthquakes and floods, desert and deep water. Crackling fire in the hills. It was an empire of smog, the asthma it gave me, that is still with me to this day. It was the empire of mountains, deserts, and weird inland seas. It was marvelous and abject. It was filled with opposites: blue mountains with white snow presiding over crispy weeds and sunbaked lots, balmy palms.

I was of native blood, Cahuilla blood. I had "Hispanic" cultural tags. But I felt alien to all groups. It was the empire of me. I was put there to figure it out.

I began photographing when I was ten years old. My first subjects were the scale model cars I carefully crafted on weekends. A few years later, my father came home with a Polaroid camera in a leather case, and I used it to photograph everything that interested me. When my father abandoned that camera, it became mine, and when he later gave up his Minolta SR-T 101, it became my instrument of choice.

While at UC Riverside, Steven Cahill taught me how to make photographs and Joe Deal, the steely "New Topographics" photographer, taught me a new way to think about the landscape. It wasn't his own way, or that of his friends, Baltz, Adams, Gohlke. Rather, he showed me how to see in the landscape a process of becoming that encompassed the paradox of empty utility and evanescent beauty existing in the same visual moment. While Baltz reduced and purified and Adams haunted and lamented, I was interested in larger forces at work.

On the surface, some might think these forces were merely industrial upheavals. What I saw was a

redistribution of power as it related to cosmology. As someone who believes certain things about the origin of the world, this knowledge dictates, almost preordains how I think the land should be treated.

I started my photographic journey with an epicenter in the Empire: Mt. Slover, where granodiorite was mined and turned into cement. The native people called it Tahualtapa, "Hill of the Ravens." The ravens were messengers between the spirit world and the human world. The Spanish called it Cerrito Solo, "Little Lonely Mountain"; were the Spanish so alienated from the landscape they could not see this mountain as being part of the valley that surrounded it? Anglo-European settlers called this place "Marble Mountain" for what they could get out of it, and they later renamed it for Isaac Slover, the owner of the rancheria at the site. This is how the world comes to be named not for its own characteristics but for men. I have made photographs, sculpture, drawings, and diagrams that examined the relationship between cosmology/language and attitude/use.

As I thought about the land and learned to look at it in my own way, I also thought about other artists, letting their perspectives trigger my own fresh ideas. Robert Smithson, Walter De Maria, Michael Heizer —they were builders, in a sense. Smithson built a paradoxical entropic paradise, De Maria built pure gestures, and Heizer hoped to build monuments for the future, cultural ruins. I began by working with my camera at night, recording on film what I was seeing in the relationships between humans and nature. My pieces also represented relationships in time. They were a mark against the size of all time. I felt those other artists were thinking too small.

During my adulthood in the Empire, I drove from job to job, teaching in Los Angeles, Rancho Cucamonga, Riverside, but every weekend my partner at the time and I retreated to a trailer in North County San Diego, at the edge of the world, facing the sea. While I spent many hours in Riverside, I spent more driving between places and wondering about it all. I took volumes of photographs that fit in between my other, more themed works.

After I left the Empire, I realized it was not just a place but an imprint that contained within its paradoxical territories both myself and my approach to art. To capture this sense, I broadened my artistic reach; as the realms of the Empire itself took multiple forms, I expanded my practice beyond photography to engage sculpture, sound, music, video, and installation work, a more encompassing practice.

■ ■ ■

For many photographers, their goal is to capture the presence of the world at a choice moment and fix it in miniaturized form on the surface of the film or sensor. There is wonder in the fact that while looking at a negative or contact print the miniaturization is so compelling one understands intuitively that all elements of the place pictured are held there. The image becomes an infinite expansion of space. But when one enlarges an image from that film or sensor and tries to bring it into a public space, there is a breakdown of the information into film grain and pixels, and the magical, private world of the artist breaks down as well. Many photographers compensate for this by using ultra-large-format cameras that allow for the illusion of the small-scale rendering to persist upon expansion. The logistics of this method are formidable and expensive, and in the high-tech era, software has become a more accessible tool for transmitting a similar experience to the viewer.

For years I have been using a digital camera with a telephoto lens to create panoramas that mimic the feeling of looking at a landscape from a moving car. To make each photograph, I click the shutter dozens of times as I scan up and down and across my view in a methodical, almost trancelike state. Software then matches the pixels of the images to each other (although not always perfectly) to combine them into a single panoramic image. Since the software's picture comes out distorted— the way it would from an ultra-wide-angle lens—I then manually correct the image so that it is no longer warped but looks more like the scene in real life. Because each photograph is made from several high-resolution shots, the resulting print has a

sharpness that creates the same profound effect a photographer enjoys when looking through a ground glass, or at a negative or transparency: the infinitude of place and detail. This process also mimics the way our minds construct images; we naturally scan, focus, and refocus, building, piece by piece, a mental picture of where we are.

In the photographic project *EMPIRE* I have punctuated large panoramic works with smaller nodes of interest. While the panoramas institute a broad public exposure, the single-frame images count as a kind of private view. In reencountering these places from my past, I felt like a ghost returning again and again to locations that witnessed moments of great invisible drama.

Although I left the Empire three decades ago and now live in the agricultural haven known as the Napa Valley, I am fossilized, like the mollusks of ancient seabeds, in the landscape of my home territory. I inhabit its paradise and its hells. No place I have experienced offers the full range of elements that compel and inspire—the vast public works, the neighborhoods both grand and beat

down, the air fragrant with citrus and acrid from smog and industry. Cool pine breezes waft off the snow, and hot blasts of wind are scented with creosote. It is the Empire. It is everything.

SAN BERNARDINO

My recollections of consciousness start in San Bernardino. First, in a little house on 16th Street. I remember a backyard with a citrus tree, a small detached garage with my father's 1929 Ford Model A pickup inside (in pieces). My first memorable toy was a crescent wrench. Kittens were also considered toys, and I collaborated with them in the backyard, creating modern cardboard houses that they enjoyed jumping in and out of. My father built an expansive white wooden fence around the yard with hard-to-engineer X's in its design. He poured a cement patio in the backyard and I remember the smell of curing concrete.

In 1958, with my sister on the way, we moved to the west side of San Bernardino. The Bench, as it is called, is a high plateau that had not washed away in the torrents that came from the Cajon Pass during particularly wet winters. Directly below it was Lytle Creek Wash, a frontierland of early twentieth-century pump houses, small temporary wetlands, sidewinder snakes, lizards, frogs, and trash of all sorts. I spent many unsupervised hours in among the sands and alluvial boulders, never at a loss for amusement and wonder. And there was

more wonder still when the rains came and the waters swept through and rearranged the once-familiar landscape along the way to meet the Army Corps of Engineers flood-control channels that guided the water to the Santa Ana River.

Mornings would always start with the same sound. The Santa Fe Railroad steam whistle on Mt. Vernon Boulevard would moan the sad call that work was to begin. The sparrows, doves, and crows would battle loudly for seeds and insects. There was the toot of the Helms Bakery truck. Sometimes the heavy patter of propellers would announce a supply plane landing at Norton Air Force Base nearby, and always the low hum of B-52s dispatched from March Air Force Base, home of the western US Strategic Air Command, would rattle the windows. I would imagine at times that the B-52s were on their final mission, civil defense sirens sounding the end of the world. I could see it in my mind painted in savage brightness and sullen ash. To a child of the early sixties, death would not come in a car crash or after a fall into a flooded gully; death would be the sudden atomization of all that we knew, and it was inevitable.

The Bench was at one time a plateau of citrus, but it had been scraped clean by bulldozers and replaced with fresh plastered ranch houses. While they were being built, my friend and I would steal little pieces of cut tile, loose nails, and odd shapes of plywood for our forts, either bunkers buried in fields behind the neighborhood church or wooden structures of long, dark tunnels in our backyards. Our most inner sanctum was where we kept hidden our pilfered *Playboy* magazines and flashlights. Our parents stopped us when we brought home smelly, dented smudge pots from the groves no longer extant, formerly vital tools of the trade that had been tossed into the gullies of the wash. We were to leave them be.

Being up on the Bench one could look down on San Bernardino. At night we could discern the grid that made the city, but even within that structure San Bernardino did not engender order. The military grid maintained a chaos of seemingly unregulated activity. San Bernardino was being constantly created and destroyed.

First came the Spanish (who named it), then the Mormons, who were tricked into the middle of turf wars between opposing indigenous groups. Next came the new Americans, who swept in like waves of difference—Spanish, Mexican, Irish, German, Japanese, Chinese, African American, and then the refugees that blew like dust from Texas, Oklahoma, and Kansas during the Depression. We Cahuilla watched it happen all around us. We were the invisible insiders. We were there among the gridded territories of difference, whose members mingled in the markets and exchanged glances at traffic lights. Lettered streets, numbered streets kept out the history and let us all float free without real suburban planning. Agriculture begat industry begat suburbs begat malls. When the upward balance collapsed, as it did from time to time, the decay and neglect compounded. Left behind were vast tracts of empty buildings that glowered like ghouls, like black holes.

The grid held together a kind of nothingness of direction, each intersection both a disaster and miracle that was visually superseded by the bulk and majesty of the mountains above. The mountains were the staid observers of the two extremes of whizzing activity and empty storefronts.

From the 1950s through the 1980s, there were stretches of months during which the mountains became invisible, cloaked behind a wall of sulfurated carbon monoxide, nitrous oxide, lead

particulates, and ocean haze. It left behind in me the panic of asthma, of strangling on dry land and days spent in bed breathing painfully and shallowly.

Perhaps I did not really understand the grid until the day I received my first car, a 1966 Dodge Coronet 500, paid for by an old insurance policy. The haze became the necessary consequence of internal combustion and freedom, and when summer came I lived at night when I didn't have to cast a frustrated eye toward the nonexistent mountains. Instead I roamed the warm asphalt ribbons, the twenty-four-hour car parts stores, the Del Tacos and Jack in the Boxes on E Street and Baseline. My friends worked on cars in their driveways at 3 a.m. holding "trouble lights" this way and that until they were too tired to continue. We fell asleep when the astringent light of day washed over the sky. My windows were covered with tin foil to keep out the smoggy light.

Then there were days when Santa Ana winds would infect the air with electricity and clarity was temporarily restored. The palms crackled and swayed, bombing the streets with their crispy fronds. Everything looked perfect. Fine dust would filter through window cracks like the sand in an hourglass. The mountains overwhelmed the chaos and shoddy home carpentry below and pointed out the magnificence of nature's presence. That was enough to remind us we were a chosen people, to be in this place while others labored in the sleet, snow, and mud.

More magnificent still were the awesome rumbles of the land shifting below our feet and pushing the ground in novel ways, upsetting my mother's crystal bells and porcelain angels, sending my books flying off the shelves and breaking water mains so that water ran down the streets the way it used to run down the trenches between the fragrant citrus trees. Freeways collapsed and hospitals crumbled, and I would trace the mysterious line of cracked plaster on my ceiling until my father sealed it up and repainted the room.

Now, thanks to modern regulations, the days are clearer, but the city still struggles to find the kind of order envisioned by the designers of the magnificent grid. Basic services cannot be rendered by a bankrupt government, so the city suffers. Individuals with vision push on, teaching, repairing glorious old houses, and creating visual and poetic culture in this place where anything is possible but rarely ever occurs.

In the early 1970s I married and we moved into one of my grandfather's houses in Colton. My grandfather collected small tracts of land all over San Bernardino and its environs, small bungalows and little apartment courts he called "ranches." In these houses, he served mostly poor single men, veterans from World War II, down on their luck and drunk most of the time. I would often be hired to paint the interiors of these little houses with toxic enamel paints, usually while the old men sat on their beds, smoking in the shadows and muttering to themselves. My grandfather had a soft spot for these lost warriors and I would often scramble into his Ford Falcon station wagon and we would go from place to place fixing plumbing, patching walls, painting rooms, and gluing down loose linoleum tiles.

I have to acknowledge, too, the other contribution of my grandfather. He was a tree grafter. All over San Bernardino, Colton, and Highland, he would carefully take one fruit tree sprig and graft it to another, creating magnificent hybrids. I Street had a grapefruit/orange/lemon/lime/tangerine tree. On Riverside Avenue in Colton there was a nectarine/peach/cherry/apricot tree. All his spare time was devoted to carefully cutting branches and wrapping wet pieces of cotton around the new joints. His trees are not unlike the structure of this place now: new sprigs grow and fruit sprouts everywhere, even where it is not needed.

My little home in Colton looked over a gully that held an Army Corps of Engineer flood-control channel, downriver from Lytle Creek. This open culvert in front of the house steered the water toward the Santa Ana River. During storms, the roar of water and debris—tires, shopping carts, car fenders, couches, and discarded toys—would roar and vibrate in a way that reminded me of the strafing B-52s of my childhood imagination.

I still drive down Hillcrest Avenue from time to time and swing around to order a #5 combination from El Taquito on Mt. Vernon, where the taste has not changed. I look north up Mt. Vernon, at all the new wires, the new buildings on the SBVC campus, and a house that has remained stubbornly shuttered since the 1980s. A few flakes of paint come down off El Taquito's neon sign, and the stainless steel counter sags a little bit more, but the beans and cheese still get crispy from the oven, and the paper plates are still wrapped in tin foil. Nowadays, the mountains abide nearly every trip. I flip through the pictures on my camera's screen and wait for my number to be called.

20 x 94 inches
34°2'28.37" N, 117°19'27.14" W

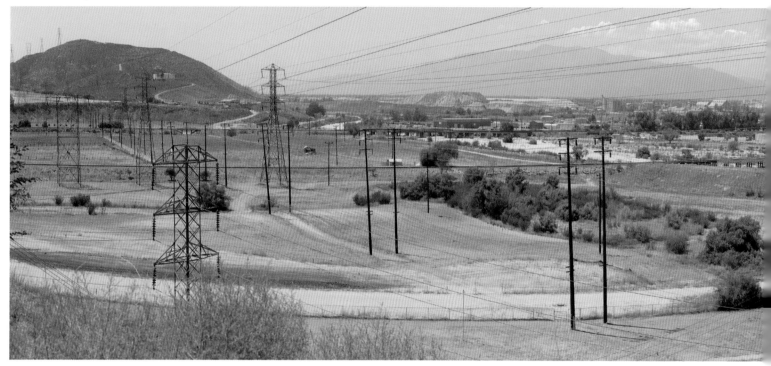

Grand Terrace, July 2012

Grand Terrace used to be known for its blue lupine flowers that burst forth in the spring. It has been many years since I've seen this phenome
on my way down Barton Road toward Redlands. Moving along the edge of the terrace, looking north, I gather a panorama of the San Bernard
Valley from ancient Tahualtapa (Mt. Slover) west to the giant building that used to house a railroad wheel factory. Now, US Rubber Recyc
turns tires into commercial flooring, and Cascade Warehouse holds 100,000 square feet of logistics space near the railroad tracks. The Santa
River used to periodically overcome this area and turn it into a muddy mass of speeding flotsam. Now delicate mobile homes nestle among
high-tension wires and the methane gas vents, everything protected from raging waters thanks to the Army Corps of Engineers. Northward,
land is stamped with corporate restaurants and tract homes. The bankrupt city looks to the mountains for inspiration.

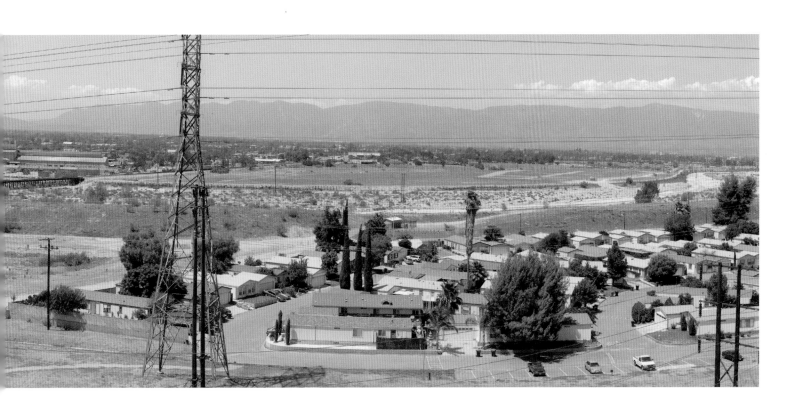

San Bernardino, North Pershing Street, west side, February 2013
13 x 20 inches

San Bernardino, North Pershing Street, east side, February 2013
13 x 20 inches

Bernardino, FMS Performance Muffler Shop, 2nd Street, August 2012
20 inches

Colton, intersection of North Mount Vernon Boulevard, North La Cadena Drive, and East Grant Avenue, July 2012, 13 x 20 inches

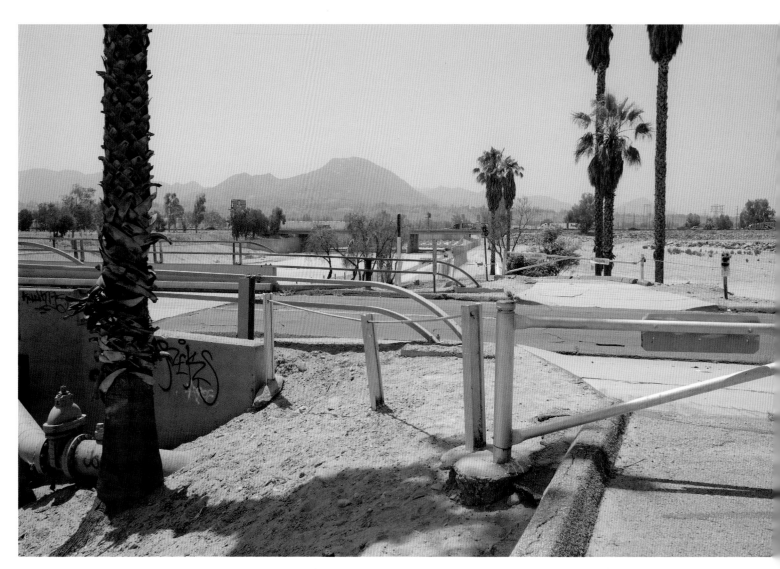

Colton, Fairway Drive at the intersection of the Lytle Creek Wash flood canal, August 2012, 13 x 20 inches

ton, Panorama Drive looking toward the Santa Ana River flood control channels, August 2012, 13 x 20 inches

20 x 87 inches
34°7'38.18" N, 117°18'6.34" W

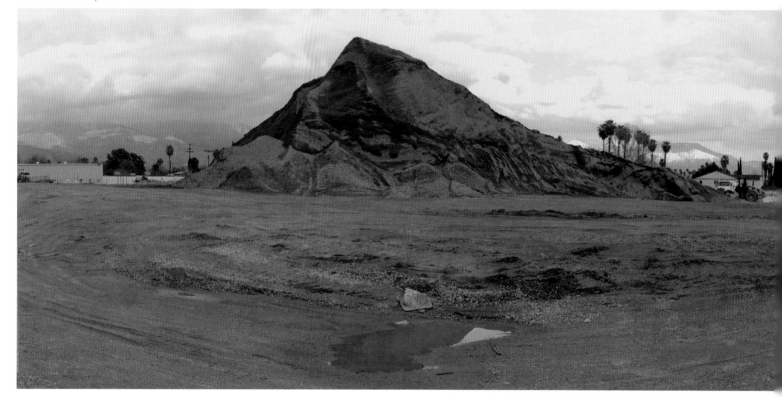

San Bernardino, February 2013

During his reign, Dwight Eisenhower determined that interstate freeway systems were necessary for defending America; their ready ability to quickly transport military materiel from defense suppliers to military bases would be vital in the event of an invasion. The popular Route 66 was tossed aside in favor of Interstate 10, and then came the interconnecting roads: the 210 and the 215 (linked to I-15), and smaller adjuncts to the mountains, like 330 and 18. Intermediary landscapes arise as these roads are constructed—mountains of trashed material (old trees, pipes, concrete, asphalt) piled high in the wake of work. Additional needed materials like sand and aggregates are distributed along the lines, sometimes out of site of the roads that are being constructed, channeled into the earth. This vast Gibraltar of sand just east of the new 215 feed road in northern San Bernardino has now disappeared into the high-speed ribbon blanketed in tire and exhaust noise.

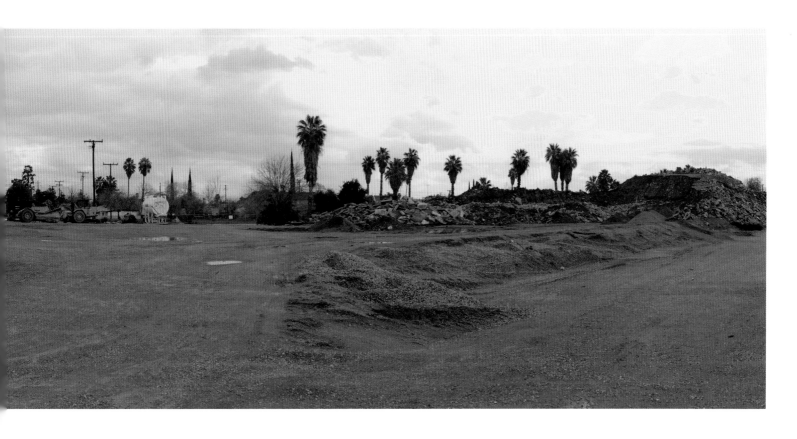

San Bernardino, North H Street, looking west, February 2013, 13 x 20 inches

Bernardino, Metrolink Station, August 2012, 13 x 20 inches

20 x 85 inches
34°9'57.41" N, 117°14'43.52" W

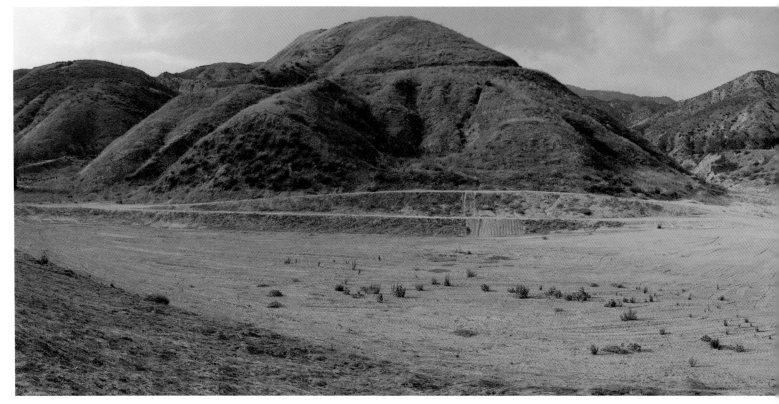

San Bernardino, July 2012

The Army Corps of Engineers has left its mark on San Bernardino County in more ways than one. Having deemed the region one of the mo
dangerous flooding areas in the United States, the corps has terraformed mountains and valleys into dams, berms, catch basins, culverts, a
canals, and orchestrated two major movements of water: one into the Santa Ana River as it heads out to the ocean, the other into the valle
aquifer. San Bernardino sits on vast water acreage as the rest of California turns to dust in the latest series of dangerous droughts. This are
above the city of Highland and the San Manuel reservation, acts as a catchment that directs water into the culvert channel just poking throu
on the right of this image. San Bernardino is chock full of inadvertent earthworks that each have their own aesthetic identity and whose o
titles can be found on hydrologic maps.

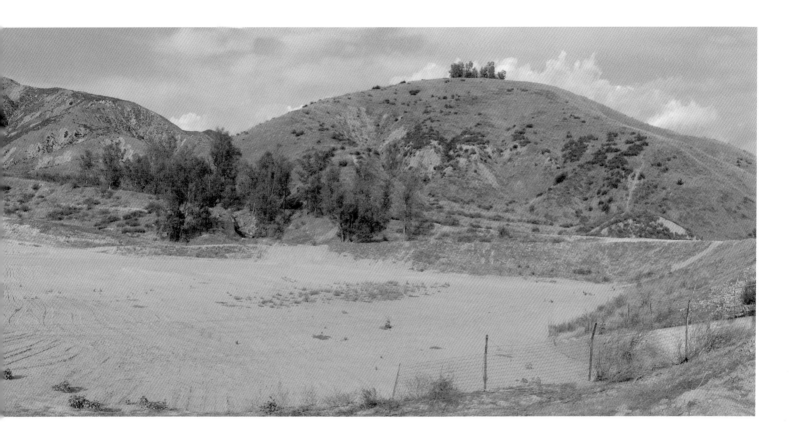

Top: San Bernardino, model home, Pinnacle Lane, February 2013, 13 x 20 inches
Bottom: San Bernardino, Devil Canyon percolation basins, February 2013, 13 x 20 inches

Bernardino, model home, Pinnacle Lane, February 2013, 13 x 20 inches

20 x 108 inches
34°11'58.21" N, 117°20'1.83" W

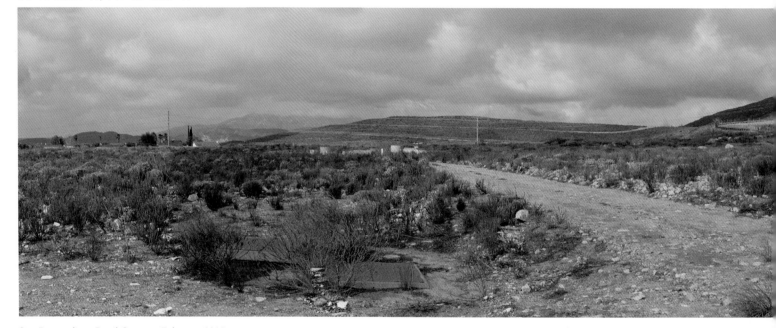

San Bernardino, Devil Canyon, February 2013

One cannot readily visit the Devil Canyon Powerplant or see the workings behind the California Aqueduct system; as I drive up Devil Can
Road, I encounter razor-wire fences and a guardhouse with armed personnel. Two hundred and seventy megawatts of power are generated
the water surging through impressive tubes and turbines at the upper reaches of the canyon. Up above and past the snowline is Silverwood La
a giant holding tank for waters delivered by the aqueduct, and a catch basin for snow and creek runoff. This coursing power is largely invisib
San Bernardino and Riverside unless one makes the trek to the massive catchments behind the campus of CSU San Bernardino. Homes rece
built on a rise above the university give residents the first clear view of their water and power.

But what does the Devil have to do with it? Daniel Sexton, who arrived in 1841, hired local natives to cut trees so he could create a gated a
where he could grow vegetables safe from browsing animals. While they were up the canyon harvesting the wood, two men fell to snakeb
As he succumbed to the potent poison, the second man yelled out, "El Diablo!" and thus the canyon was named.

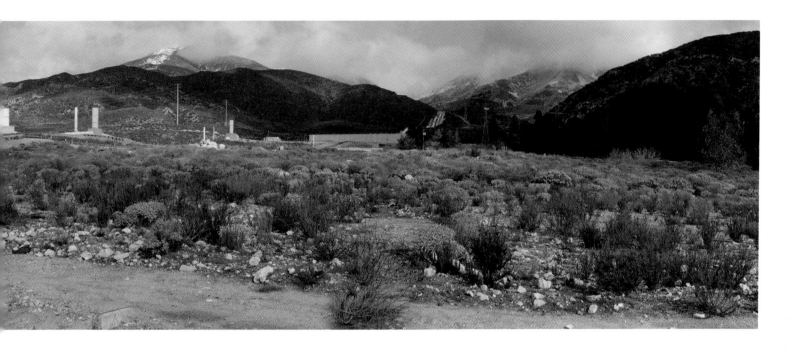

ONTARIO
RANCHO CUCAMONGA
FONTANA
RIALTO

It was in 1965 that I first saw my father cry. One long day, my sister and I were wearing our Sunday clothes and my father and mother were dressed somberly. We took the 10 freeway to San Gabriel. That day we buried my Aunt Margaret, my father's sister. After seeing the strange box go into the ground, my father held it together until we got back into our beige Chevrolet station wagon, at which point he wept loudly and violently. A rift opened in the world.

My father drove out on Duarte Road until we found Route 66—Foothill Boulevard—which we'd take instead of the freeway. I stared out the window, my hands running along the ribbed vinyl upholstery. I wanted to roll down the window and put my arm out, but I thought any show of exuberance would be inappropriate. Along Foothill Boulevard I contemplated the few buildings that were there: gas stations, motels, liquor stores, the Sycamore Inn. There were many fields punctuated by large white boulders. By the time we got to Ontario, it was windy, the Santa Anas having started their assault.

As we arrived in the town, I inhaled the sweet smell of citrus and then, alternately, the fragrance from the rows of vineyards. Most of them were fallow, with dried weeds and stark, leafless vines. Where water had pooled, the vines were green, running crazily outward. Beyond those islands of life, there were halos of blackened vines, haunted silhouettes, death. My aunt was dead. I felt the link between her and these acres of tormented grape stock, and sadness settled in as fine sand from the winds engulfed the fields around me.

Soon we were in Rancho Cucamonga, and I could see in the distance some ancient stone buildings, the Guasti family's winery. The stones had been sourced from the great alluvial fan that spilled out from the Cajon Pass, and there are still several farmhouses in the area made of these tumbled rocks. The few olive trees we passed looked parched. In the eastern distance, lines of willowy eucalyptus trees bowed to the wind.

Cherry Street. We could see the stacks of the Fontana steel mill, created by Henry Kaiser at the

beginning of World War II. One could see the haze blowing southward from the plant, and I was thankful. My asthma would not be triggered by the acidic cloud.

Fontana was the source of both disease and deliverance. On days when haze and smog would predominate in the valley, I would sit in the school-yard, fighting for breath, sometimes coughing up gouts of phlegm to be hastily spit out in the grass of my elementary school in Rialto. There are nights I remember being carried to the car and driven toward the source of my torture—Fontana—en route to Kaiser Hospital, where I was force-fed oxygen and shot full of adrenaline.

Saturdays, my father would drive me to the allergy clinic, where I would get injections intended to keep my body's aversion to the physical world in check. It was on this journey I learned the tree names; as we drove from the edge of San Bernardino through Rialto and Fontana, each north–south street called out a different species: Pepper, Sycamore, Eucalyptus, Willow, Lilac, Cy-press, Cedar, Tamarind. Palmetto was the last street before the hospital's property began. It was there that I fell for a classmate who received similar shots. Our common plight must be fate, I thought, yet at school we never mentioned our shared weakness, the shame of being flawed.

On our return, my father would allow me to spend some time in the Rialto Public Library, which today still looks much as it did back then, with a cast concrete façade and the interior divid-ed between children's books and adult materials. I never bothered with the children's side, having already systematically read the entire library of Myers Elementary School. The school librarian urged me to get a public library card with adult privileges. She wrote a letter to the library plead-ing my case. Soon I was checking out science fic-tion, sports history, and architecture books. Frank Lloyd Wright was my hero, and I started looking at the stucco-sprayed boxes that comprised my built environment with tortured disdain.

Lilac Street. My father's sister and her family lived there between Foothill and Baseline. After winning a lawsuit in the early 1960s they had purchased the pink house with a pool and then bought two pink 1964 Thunderbirds. My secret fear was that we would go there after the library and I would be submitted to the experimentations of my cousins. There were always various humiliations and trials designed to look like innocent play. My aunt, who was discovering her Indian Pride, would read her rhyming poems while my uncle would drink and yell. His face was continually frustrated and sad. My father would have one beer, periodically sprinkling a little salt into the can. Within a few years, their lawsuit money was gone, the Thunderbirds (Indian symbols, surely) were wrecked, and my cousins went their various ways, into drugs, into prison and, on the good side, into lives as teachers and business people. My aunt wrote a "book" on a spiral pad for me in pink ballpoint pen that laid out our tribal lineage, a document I still refer to today.

It is now hard to find a vineyard in the western part of San Bernardino County, though there are still a few vintners that produce. Even dead vineyards are as rare as living ones. Only if you look closely will you see shadows of the dairies, egg farms, and citrus orchards that predominated in old Fontana. In 1993, when the Capital Iron and Steel Corporation of Beijing came for the steel mill, carting it away, piece by piece, bolt by bolt, Fontana became a kind of living ruin. Later, the former hub got a second chance when the Auto Club Speedway was built on the steel plant's former site.

In the next ten years, stucco was being sprayed over more elaborate boxes, clusters of inexpensive homes that fed the need for affordable housing for Los Angeles County workers. The straight main streets of the Army Corps of Engineers remained, but within the grids were mazes of culs-de-sac, curvilinear streets that witnessed the beginnings of two-story homesteads and the constant sound of lawnmowers, leaf blowers, and garage-door openers hiding the oversized Ford F-150s and Lexus SUVs. Turning north of old Route 66, there is still a rare farmhouse between the groupings of medical clinics, fast-food establishments, Starbucks franchises, and Stater Bros. Markets. Within the confines of the greater grid has grown a new concept of utopia, one that turned away from the cooperative farms of the

windy alluvial fan to what looks more like a village full of castles, with now and then a wide swath of green dotted with little triangular flags. Sometimes on the long straightaways of tree-named streets you will see skateboarders coasting south, no need to propel themselves with a push against the concrete since all the streets run downhill and south, heading somewhere, someplace…else.

In 1958, my parents moved from their little house near the Barbara Ann Bakery factory and placed their hopes on "the Bench," on the mesa above the fray of lower San Bernardino. The Rialto city limits were across the street from our corner on North Meridian Avenue, and to the south lay Route 66 and a pick-your-own strawberry patch. Just west of that was the famous Wigwam Motel, which became the symbol of my neighborhood, and of America's love affair with the highway. Across the street from our new maple-floored house were fragrant orange groves. Before the bulldozers' arrival leveled the farms, my father had the idea to grow a lawn out of dichondra, which would never need mowing, but that dream was destroyed by the dust and weeds that blew off the flattened groves. Where the dark trees had once held a mysterious, silent power at night, now there were rows of dim yellow street lamps in front of small, cheap houses pushed close together. The sounds of crickets, mockingbirds, and nightingales was replaced with crying babies, barking dogs, arguments, and barbeque parties.

North Eucalyptus Avenue. Junior high school freed me from the daily trudge up the street (alone) to elementary school. Now, my bicycle took me to the brand-new Frisbie Junior High, all red brick and concrete. While the bike ride was a welcome change, I considered school itself my prison camp. I was made to undress in front of others in gym class and run around a smoggy track, my asthma taking such hold I would have to sit, humiliated, at the quarter-mile mark as I tried to take a breath, my inhaler once again forgotten in my pants pocket, entombed in my gym locker.

These days the school is hurricane fenced and heavily surveilled. There is no video record of my anxious time there, when I secretly loved the blonde who sat in front of me in social studies. She read Marx during break and was taking German class. I could never imagine to be that smart. My isolated mind, where the only network was a television station that broadcast *Star Trek*, only dared imagine other worlds, other places.

Now I dream of those views from the schoolyard to Mt. Baldy, remember the fresh electrical feeling in the air as the Santa Anas began to blow or as the sky became dark before a rare rainstorm. The pine smell as snowy air blew down from the San Bernardinos. I follow the straight lines. I trace Baseline Road up to the very peak of San Gorgonio and then back and out to somewhere in Claremont, where it concludes very near to Damien Avenue, my middle name.

Baseline, between North Lilac and North Willow. Follow the perchlorate in the well water south down Sycamore Avenue from northern Rialto and there, built on rocket-fuel-soaked earth, is the site of my high school. It was named for Eisenhower, a legend of a president—old, erudite, in command—but also a general who hated war and a general who did not trust interdependent industries that generated the hardware, explosives, and fuel to power the planes and missiles that would deliver the fatal blows to our enemies. Eisenhower High School was built in the Inland Empire, replete with nondescript buildings housing aerospace and military-supply companies, including Lockheed, TRW, Bournes, and many others that surrounded the air force bases in San Bernardino and Riverside. They stretched out to General Dynamics in Pomona, where my father worked but could not speak about what he did.

Eisenhower High School, stranded between the fragrant Lilacs and sad Willow trees, was the high-tension environment where adolescents of the early 1970s flexed their hormone-laced muscles under nuclear threat at the peak of the Vietnam and Cold Wars. My asthma was lessening and I found I could play tennis in one-hundred-degree heat without too much strain. I studied drama and wrote plays, short stories, and ridiculous poetry. I drove my father's reassembled 1929 Ford Model A to class when the mornings were warm. Other days my 1966 Dodge Coronet 500 filled my need for refinement. I began to understand the joy of all those straight streets, and being out at night during the summer helped me avoid the strangling opaque smog of the day. Cars and girls were an irresistible combination of pleasure and passion.

At this point in my life, the world turned into a stage. A stage that had the scope of the history of man yet reduced to the particulars in my immediate field of experience. The Del Taco on Baseline,

the Baskin-Robbins on Foothill, the abandoned Kmart across from the Fantasy 66 adult bookstore were cardboard sets for the emotional texture of the world through the eyes of someone who wanted to be in love and who had expansive dreams about what all this creative energy boiling inside could mean. There are other dreams inhabiting this place now. Dreams of those who see the peculiar polyglot language of the place, its architecture of corporate regularity, the diaspora of immigrants, and the rise of a new, rich Native America.

In this network of unnatural *things,* however, there are also nurseries and greenhouses filled with exotic botanical specimens from all over the world. Someone has realized that here is a place new life might flourish, might once more populate the barren vineyards and potential strawberry fields. In Rialto, the Wishing Well Nursery of my childhood has become the Enchanted Nursery. It is stocked with possibility, ready to supply the necessary backdrop for a renewed paradise.

20 x 83 inches
34°2'34.04" N, 117°34'37.13" W

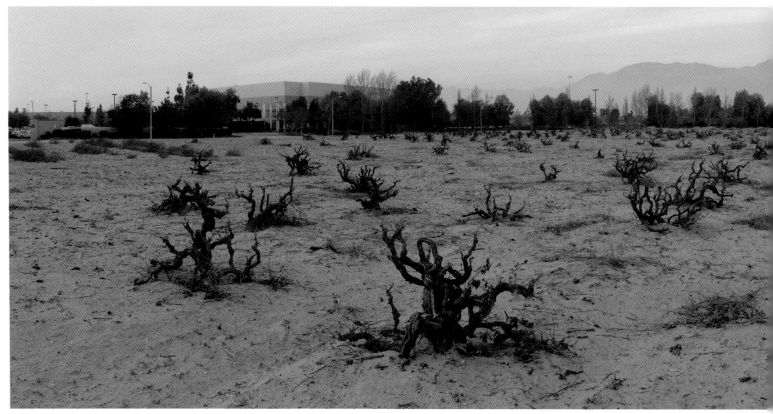

Ontario, January 2014

The vistas of vineyards along Route 66 and the Christopher Columbus Transcontinental Highway (aka I-10) are now a collection of concr
logistical warehouses, shopping malls, and the Ontario International Airport. The ruins of a winery complex stand wrapped in white plastic a
sealed off by chain link and padlocks just north of the runways. In the distance a FedEx jet taxis, and in the foreground the Santa Ana winds b
sifted sand onto crowds of black vines. When spring comes, they will push out leaves and Sangiovese Piccolo grapes that will ripen without
vine trimmers, without a harvest.

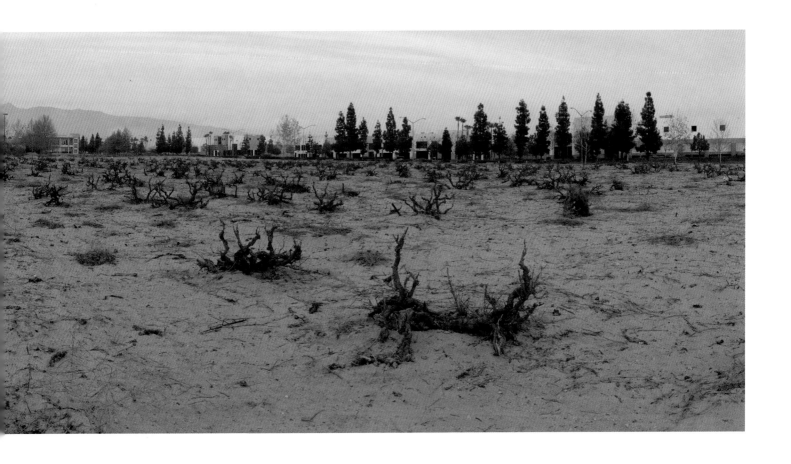

Foldout: In 1947, writer and philosopher Ayn Rand visited the site of Kaiser Steel and studied the routines and working techniques of the plant. She based her fictional Rearden Steel company, from the novel *Atlas Shrugged,* on this visit. The Kaiser plant reigned in the area from the 1940s until 1993, when it was taken apart piece by piece and shipped to mainland China. The site is now home to the Auto Club Speedway, an immense NASCAR racetrack. When I took this photograph, I was standing between the speedway and land owned by California Steel Industries, within sight of the railroad line that once had shunted steel and materiel to and from the former plant. The air is crystal clear now, but the sky used to be orange with sulfur and other toxins, which would blow eastward and destroy the precious products of the Southern California citrus, wine, and dairy industries. California Steel Industries is still one of the largest such sites in the region, and is perhaps most famous as the place where the Terminator robot met its demise in *Terminator 2.*

20 x 160 inches
34°4'59.12" N, 117°29'34.61" W

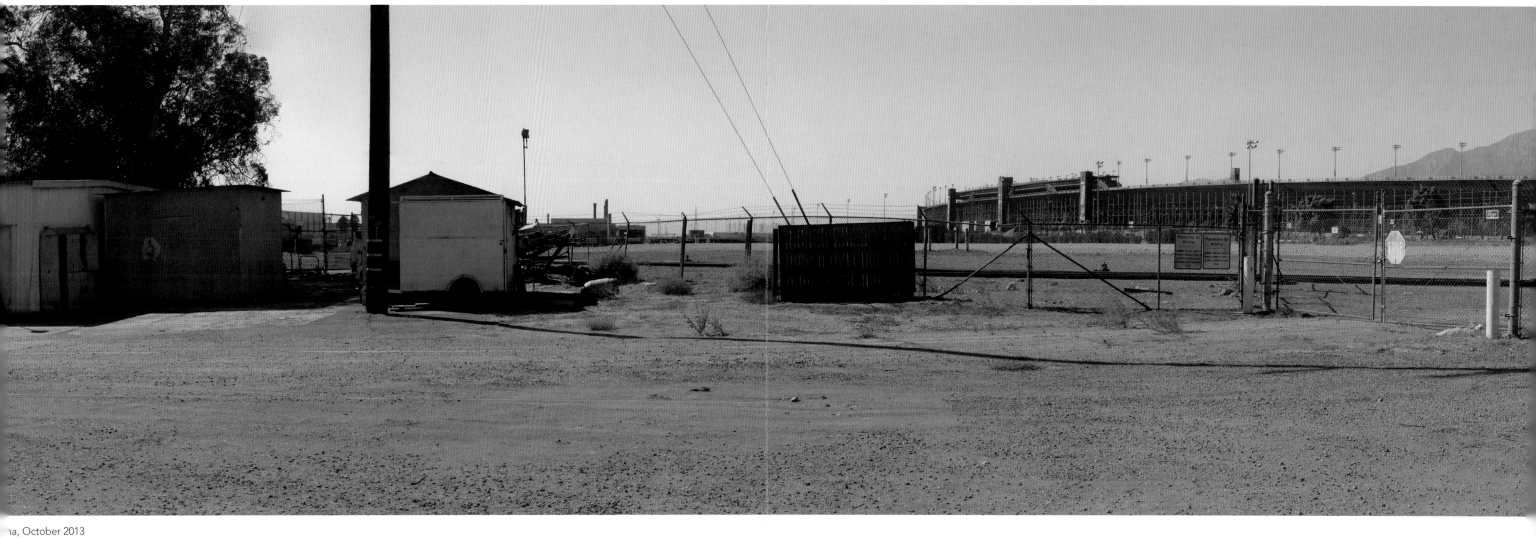

na, October 2013

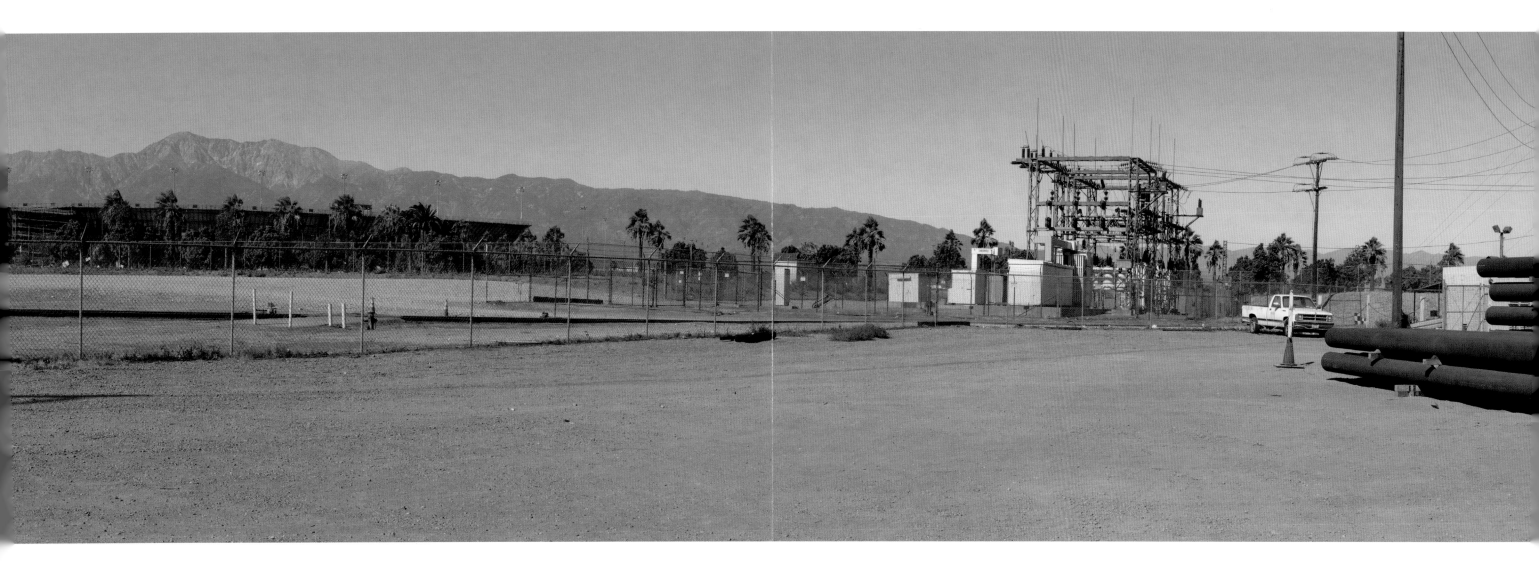

Fontana, mountain of coke tailings, California Steel Industries, San Bernardino Avenue, October 2013, 13 x 20 inches

Fontana, Sierra Lakes Golf Club, Augusta Drive, July 2012, 13 x 20 inches

mington, Slover Avenue, October 2013, 13 x 20 inches

Agua Mansa Industrial Corridor, Slover Avenue, October 2013, 13 x 20 inches

20 x 124 inches
34°3'19.27" N, 117°22'9.16" W

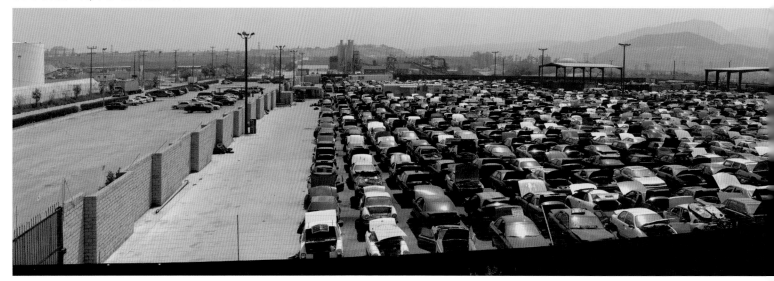

Agua Mansa, July 2012

Agua Mansa means "gentle water," ironic given that in 1862 a major flood of the Santa Ana River overran the area and wiped out an encommunity. This site, along with an adjoining village called La Placita, was one of the first European settlements in the region, and despite vous hardships (an early adobe church was swallowed by quicksand), the people lived there from 1845 to the time of the disastrous flood, whdestroyed everything but the cemetery just south of the location pictured here.

On the left of the image is a truncated mountain, Mt. Slover, named after Isaac Slover, who died near the Cajon Pass in 1854 from a gribear injury. This mountain, known as Tahualtapa to the Cahuilla (meaning "Hill of the Ravens"), was later mined for granodiorite, a comporused to make cement. This cement became the buildings and roads that later brought a flood of cars to the region, and those cars in turn wbeaten by the same roads until they eventually ended up in local junkyards, a flood now fished for parts and scrap metal. Agua Mansa is novindustrial center where logistics, salvage, cement, rock crushers, and gasoline refiners continue to attract still more floods of people to the aboth those who come to live and those who merely pass through.

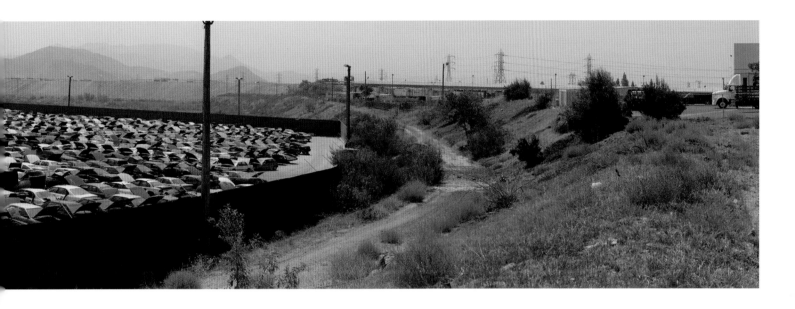

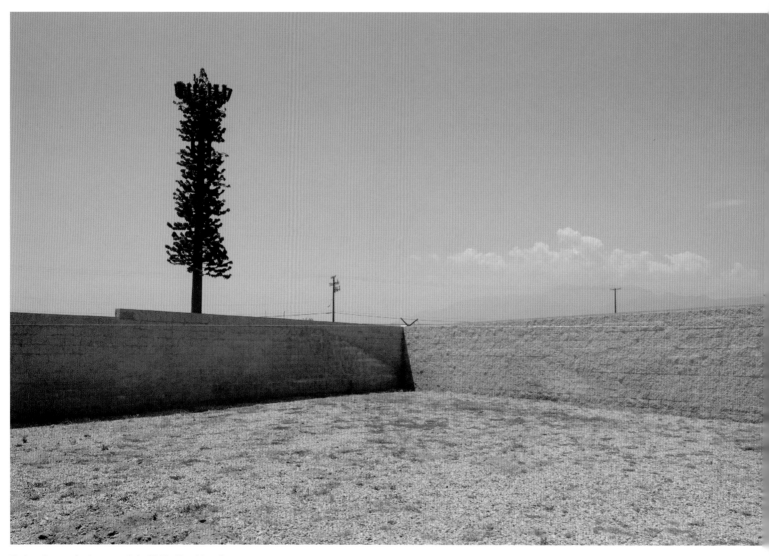

Rialto, Riverside Avenue, July 2012, 13 x 20 inches

to, North Meridian Avenue, July 2012, 13 x 20 inches

REDLANDS

Politana, the first Spanish settlement of the southern highlands of the San Bernardino Valley, was founded in the early 1800s as a supply station for the Franciscan mission system. Before the Spanish came, these highlands were home to several native groups, including the Serrano (Taaqtam, Maarenga'yam, and Yuhaviatam), who were largely Christianized and forced to give up their former way of life. The Cahuilla, meanwhile, resisted the missionizing efforts and were able to maintain for a time amicable ties to both Spanish and American outsiders.

Juan Antonio, one of the last Cahuilla horseback chiefs, had collaborated with Spanish American Californios to attack the Luiseño/Payómkawichum in the Temecula Massacre of 1847, and he had also coordinated with the US Army on an assault on the Ute, after which he proudly wore army epaulets given to him by an American lieutenant. Juan Antonio presided over the Cahuilla in Politana for many years, until he and his people were driven from the area after a small group, led by Juan Antonio, turned their violence upon white men. The American settlers, who had not flinched when Juan Antonio had fought against other native groups, became alarmed when the chief and his followers went after Caucasian criminals, and when a militia arrived to guard against a potential Indian uprising, Juan Antonio and the Cahuilla left Politana, never to return.

As the Orange Empire grew, Politana became Redlands, and the area's sweet largesse paid for expensive mansions, delightful libraries, a symphony, and insulation from the masses in the lowlands of San Bernardino. My parents stayed out of Redlands, not out of reverence for this hotspot of roiling historical activity but because of well-known real estate policies designed to keep the brown-skinned ancestors of the Spanish and natives out of this enclave of supposed civility and order. While ghosts of the past appeared in the arched Spanish-style homes of these highlands, the only symbol of the region's Indian roots was along Orange Street, where once could be found atop a local store a native swastika symbol (now covered up). If one went looking, perhaps the fos-

silized hoof prints of Juan Antonio's steed could be found in the hardened mud erupted from San Timoteo's hot springs during 1812, *el año de los temblores.*

My newlywed parents were confined to the area around Baseline and Mount Vernon Streets, where the new freeway had no off-ramps. It was there an enclave of Latino businesses was allowed to flourish, including the Azteca movie theater, the tortillarias, and the sole-surviving Mitla Cafe. By 1958, my parents managed to move farther west to the bluff overlooking the valley to the east, but Redlands proper was still a world apart.

Trips to Redlands were mostly confined to visits to the home of a highway patrol officer, a friend my father had made at Norton Air Force Base when they were both mechanics. Our other Redlands custom was to drive on Christmas Eve to admire the rich light displays decorating the houses set back on their gracious lawns. It was on one of those nights that I saw a UFO, a glittering silver lozenge of a craft hovering over the San Bernardino Valley, glinting in the dying winter light. Perhaps it was a trick of the eye, the light reflecting off the fresh snow near Strawberry Peak in the San Bernardino Mountains, yet some instinct told me I was supposed to be on that craft. They were looking for me; I was not really from this time and place. My parents were unknowing victims who had an alien for a son. I don't think they ever found out.

It wasn't until my late teens and early twenties that I made more regular visits to the orderly planted palms and echoes of orange groves in that forbidden land. I drove along the southern edge of the city, where I could look down into San Timoteo Canyon. I felt drawn to look but not to explore it. Something always held me back; it all felt hidden and tragic. The train tracks running through the center of the canyon seemed an imposition.

My future wife was a student at the University of Redlands, the former Baptist college turned liberal arts bastion that spelled out the exclusivity of this territory built on white exceptionalism. From the carved sandstone details of the Smiley Library to the set of arching benches facing the Redlands Bowl band shell, this town was part of an

archetypal American culture. Anne and I would ride bicycles along the avenues lined with Victorians and Spanish mansions and imagine we lived on these shady streets. Everything there was available to us. It was an ease of feeling that we never experienced in our workaday lives.

Sundays found us dining with her stiff grandparents, her sister, and her sad mother at Griswold's Smorgasbord off the Ford Street off-ramp of I-10. There was something glorious about the Mills family, as the elderly pair repeatedly told me over dry turkey and gravy and bland warmed potatoes. Their veiled language vaguely acknowledged the prerogative of their past, and I believe it was done both to impress me and to illustrate that I had no place at their table, despite the inclinations of their granddaughter's heart. They laid out in front of me the markers of their privilege—the family tradition of sending their children to Redlands University, the contributions to the symphony—and at nearly every meeting there was also the unfortunate but inevitable reference to the death of Anne's father in a car accident. Grandmother Mills would cut out tragic crash clippings from newspapers seemingly to remind her daughter, Anne's mother, of her

unfortunate choice of a mate. How things could have been different if she had only listened to her parents.

I became the subject of the Mills family's value system. I was complimented on the fact that my upcoming marriage to Anne would be a great boon to my status in life, a lift up from the (implied) life of a dirty Indian or sweating Mexican into the clean air of civilization and moral certitude. That is when I walked out. That is when Redlands changed. No longer a daydream of waving palms, orange blossoms, and bay windows looking into the smoggy sunset, it was once again the battleground of my ancestors.

The Mills family did not attend our wedding, and I did not take the Ford Street off-ramp again. This was my turn away from the fantasy of easy equality; it was my acceptance of the reality of living in a salvaged house across from a drainage ditch in Colton. It was the reality of the twenty-five-cent ramen bricks we needed to sate our hunger.

Then came the conclusion of our marriage; ultimately our young minds could not bend enough to see through the disappointment of our situation, both what was inherent and what we our-

selves had created. Our parallel aspirations of becoming artists and intellectuals of some import were too difficult to share as a couple. Neither of us had been trained in love and support; our understanding of adult relationships was *jejune*, cut and pasted from novels and movies.

Anne moved out and her mother called incessantly; I told her she was shopping, working, studying, but I really did not know where she was. I drove late at night into Redlands, into Riverside, always suspecting I would see her through the window of a fine house, settled with her real family.

Finally one day a police officer came to my door. It was now obvious that the Mills family believed I had murdered Anne in a Latino/Native rage, perhaps scalped her and eaten her body. Instead the officer found a bereft person who had not slept in days, who was beset by asthma. She advised me to get some help, wrote down the number for a suicide hotline, and told the family I was not complicit in Anne's imagined demise.

I was relieved to see my mother-in-law's big Buick pull up to the house with Anne one day, even though it was not a homecoming. They were there to gather her clothes and books and whatever other trifles we had kept together. Her mother seemed embarrassed, angry. Anne stared through me, numb. I understood then that Redlands, that Politana, was lost to me, too.

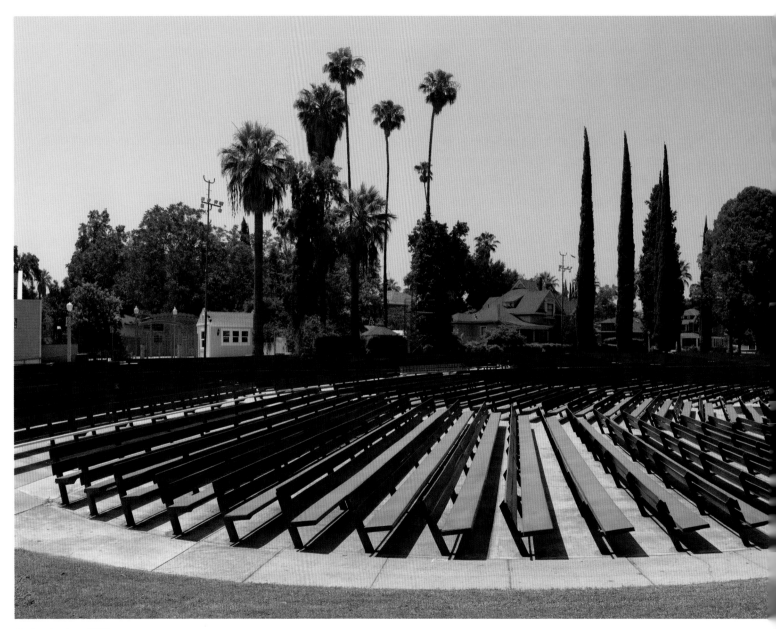

Redlands, June 2014

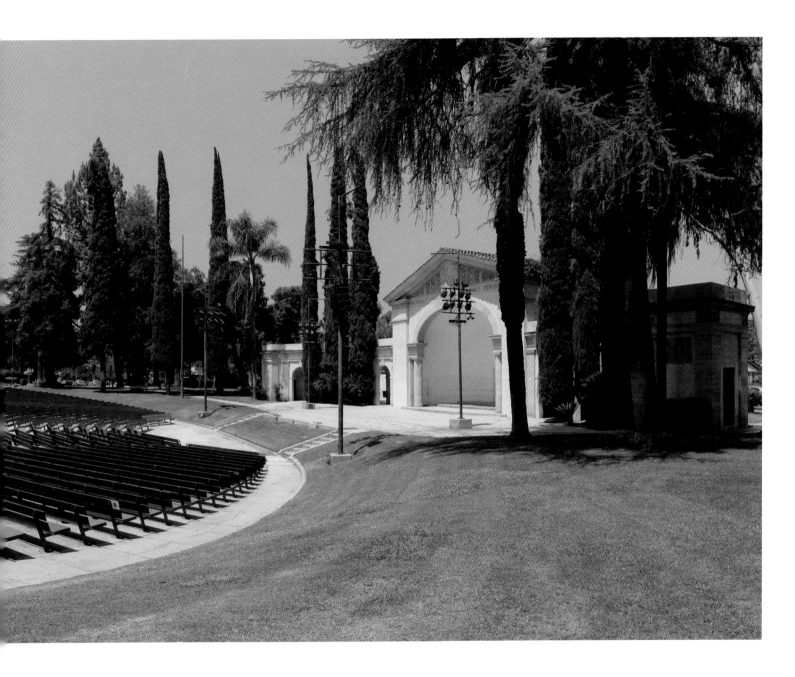

Previous page: The Redlands Bowl amphitheater sits in the heart of Redlands' central municipal district. Flanked by large, regal, late nineteenth- and early twentieth-century homes, the bowl seems to expand into them, an effect that creates an unusual sense of intimacy between private and public space. Over the classical portico read the words "Without Vision, A People Perish," a sentiment grand and inclusive. Redlands originally tried to protect itself from people it considered outsiders. Laws guarded against incursion by brown, yellow, black, and red people. During my visits during the early 1970s, I felt the exclusionary glances while the symphony played Tchaikovsky's "Sleeping Beauty Waltz" too slowly and mildly out of tune. My date at the time, a lovely blonde girl with uncannily blonde eyebrows and eyelashes, slept soundly, my jacket around her shoulders.

20 x 55 inches
34°3'12.79" N, 117°11'4.25" W

ands, West Olive Avenue, June 2014, 13 x 20 inches

West San Bernardino Avenue, Redlands, January 2013, 13 x 20 inches

Redlands, Dearborn Street, January 2013, 13 x 20 inches

aipa, Bryant Street, January 2013, 13 x 20 inches

San Timoteo Canyon, Redlands, January 2013, 13 x 20 inches

20 x 99 inches
34°1'13.12" N, 117°9'12.12" W

Redlands, June 2014

The sun sets on the San Bernardino Valley, playing light across the grand ridges of the mountains and up to the crown of the valley and high peak in Southern California, San Gorgonio Peak, at 11,503 feet. Along the southern chain of homes in Redlands, abutting the river valley of Timoteo Canyon, the residents have the grand vision of the valley toward the incoming ocean haze (and smog) from Los Angeles. Amidst trees flit species from the greatest variety of migrating songbirds in Southern California.

Opposite page: "Nothing going on here," my mother would say when I would check in with her on the phone. She had three opinions about the weather. Cloudy was "dark and miserable," sunny was "nice," and windy was "awful." When she ventured out from her home with my sister, they went to a script of about ten places: Kaiser hospital, Stater Bros. Market, Costco, Taco Joe's, the Lotus Garden, Chase bank, Montecito cemetery, Carrows, Ned's Hardware, and Macy's. While my father ranged from Santa Barbara to Palm Springs, with visits to me while I lived in Seattle, my mother's sense of home created a gravity well that she rarely wished to leave. In her voice I could hear that my mother found human life boring. Her script rarely varied from the cause of her sufferings, her physical decline, my father's death, her large family's infighting, the refusal of her nieces and nephews to call her.

Her interest was kindled by the presence of flora in her life, citrus trees, bougainvillea, hibiscus, and camellias. If I drove her somewhere she would wonder at the trees, bushes, and flowers when she was not reciting her prescriptive grumbles.

When my father passed in the late nineties, his presence lingered for long past a month. I felt him looking down on his children, full of love and pride. Ten months later I had a radiant dream where he spoke to me over a brightly colored radio in a train station I recognized as being in Seattle. He was laughing, "Son, you won't believe it when you find out, it is so FUNNY," he kept repeating. Later that morning I saw the radio in a Toys"R"Us ad in the paper. A baby monitor. My father's force of life took him to the Northwest, which he spoke of fondly.

My mother passed this April, in the morning on a nice day. Her absent corporeality has not yielded any visitation. I feel she must be relieved to be free. Perhaps she attached herself to some seed planted by a covetous western scrub jay. In time her leaves will grow and turn to the sun, following the shining arc of life to the orange passage into night and wait to be nourished again.

lands, West Sunset Drive, June 2014, 13 x 20 inches

HIGHWAY 18

A highway can be its own place, not just the places it connects. It is a series of choices to be made, some fatal, some an affirmation of life. Since car keys first found my hands, I made the decision to challenge myself to reach some kind of alpha state on Highway 18. I referred to it privately as an "orchestration event," in which all the aspects of driving and being were intertwined into a kind of cinematic experience; where music, machine, speed, fragrance, temperature, vistas, and consciousness melded into a ribbon of time that described a state of awareness.

Highway 18 was where I discovered brake fade and the completely terrifying experience of being unable to stop a 1966 Dodge Coronet 500 on the downhill, four-lane portion of a road. It is where I learned to cut an apex. It is where oversteering could feel at once poetic and terrifying.

Highway 18 begins where Waterman Avenue heads north and begins to rise up from the flat plane of the valley floor. I usually turned right onto Waterman Canyon Road and drove north, climbing toward the next intersection with the highway.

This canyon road was a series of tight switchbacks that passed the entrance to the formerly glorious Arrowhead Springs Hotel, where rich Hollywood folks took the waters under the miraculous living symbol of an oversized stone arrowhead jutting from the mountain above. The funicular was long gone, and at the time of my journeys, the building was owned by a Christian cult. At the gateway stood a bronze of an "Indian," his head feather cocked toward the hotel, arm outstretched in welcome…or perhaps he was there to warn people to stay away?

As I climbed the canyon, I came under the spell of sycamore trees overhead. This beautiful canopy was more intense, I found, in the open cockpit of a convertible. My first was a 1967 Datsun Roadster, which led to two more of the friendly little Japanese cars before I gave up on the marque. A rusty Corvair Monza convertible also paraded here. These cars provided the mettle for me to race against myself up the mountain road.

Crestline, Sky Forest, Lake Arrowhead, Running Springs—they were not really places but touch

points, markers in my journey up and down the mountain. Lake Gregory, the Rim of the World restaurant, where on a clear day I could see the arc of the sea and Catalina Island. These were my brief rewards along the way.

This ribbon of road became the zendo for my peculiar form of meditation. A series of cassette tapes filled with my own brand of British jazz would format the experience; as I drove east through the valley floor on Highland Avenue, then turning left on Waterman Avenue, I would gradually empty my mind of thought. I was preparing my body to take in all that was happening, the smell of smog and exhaust transmuted to mix with pungent smoke from fireplaces in the alpine heights. Then there was the sound of the car's engine laboring against gravity, the feel and slip of the tires as traction was found and lost and found again. The temperature, dropping from the nineties to the sixties, sometimes freezing in the clouds cleaving to the mountain above. The music tied it all together with its rhythms and improvisations. When it was right, I could reach an ecstatic state, where the "place"

that I was and my "being" in that place intermingled with the staggering vistas beyond the boulders set along the edge of the highway. I would drive until my fatigue allowed the intoxicating feeling to leave me. I would rest where I landed, sometimes with a sandwich in a paper bag or a jaunt to some diner or market to get recharged.

Each car had its own songs and capabilities. Sometimes the limits of horsepower and traction were what made the journey so electric. Because I had limits, I could see the barriers to be crossed and those that could never be.

There were other monuments to be noted, including the Mozumdar Temple in Crestline, that vaguely Moorish, onion-domed block of white building among the trees. Sometimes the road leading to it was left open and I would tramp along it and walk into the building, a kind of semi-ruin to a universalist religion. The Village at Lake Arrowhead, which consisted of one good supermarket and some tourist stops and restaurants, was not a place I abided, but sometimes it was my turn-around point. A kind of chalet of

noise sat in the middle, full of pinball machines and other noisy tests taken for a quarter. The lake, a privately owned artificial body of water, almost claimed my life when I was twelve, on a family outing by the little stand of sand that counted as a beach. I was pulled into the cold green algae maw by the hidden current, and my parents did not see my panic when it happened. Somehow I stopped my descent and struggled back to shore on my own. Why didn't I know how to swim?

Earlier that morning I was part of a tourist ride on what looked like a little riverboat, and even safely aboard I had felt trapped. The guide's words were distorted by the PA system, but what I heard was not reassuring. Something about how the owners of the land held the lake as a private reserve for their own privilege. How Lake Arrowhead began as a promotion for the *Los Angeles Times*. Something about Liberace having a home there. Who cared? The boat was stiflingly small and I wanted to return to the wide land.

Santa's Village, the first franchised theme park in America, was in nearby Sky Forest, but I never went. My parents were not bamboozled by the dressed-up elves or the boys in lederhosen showing people onto bobsled rides. Christmas had long since devolved from a joyous acquisition of toys and baubles to watching my parents open their presents with a little disdain; it seemed they could not figure out what each other wanted. Santa's Village was the land of disappointment and cold, trembling winds. Pneumonia, perhaps.

The frozen delights and exotic snow to be enjoyed off of Highway 18 at certain times of year were usually brief. The season of mountains dusted with icy-fresh snow, the people locked into their A-frame retreats...that only lasted a month or so. During this time people parked their cars at the mall, each roof covered with snow from Big Bear Lake. Ski racks and palm trees intermingled at the McDonald's and Baker's burger joints.

As I return from the high-altitude fantasies of skiing, hot chocolate, and hearty fires on stone hearths, I could still smell the fresh pine needles down in the desert, and there was a chill in the shade that flashed away in the sun.

Years before in my parents' backyard, before the orange trees became too big, I could ride the swing's saddle up and up to see over the fence, and as the sun went down, it would strike the white face of San Gorgonio and create a gold and lavender light on the west side and a bluish ma-

genta hue in the east. As I swung back and forth, the light would shift darker. I would start to see the twinkle of lights, cars traveling on Highway 18 just below Strawberry Peak, where the forest rangers with binoculars trained their lenses on the bobbing heads of swinging children below.

20 x 75 inches
34°13'36.36" N, 117°17'0.09" W

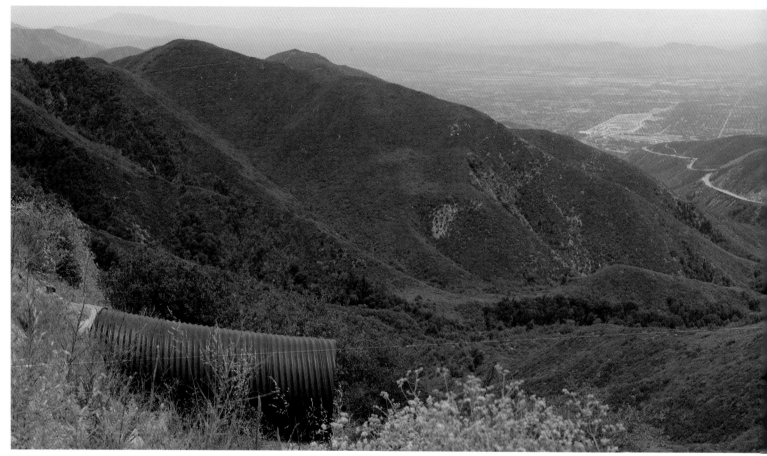

Highway 18, June 2013

A little over twenty-five miles from San Bernardino's heat, smog, and variations thereof is the cooler alpine air of Crestline and Lake Arrowhe
If you follow Highway 18 all the way, you pass Big Bear Lake and then double back west to end in Apple Valley in the high desert. The L
Arrowhead run became a racetrack of sorts for me to test the engines, tires, cooling systems, and brakes of various sports cars over the ye
including a group of three Datsun Roadsters, a Triumph GT6, a Volvo P1800, and two different Opel 1900 variations. Between sprints, I would s
at various traffic cutouts and observe the valley below. This photograph was taken just after the four-lane section runs into the narrow two-l
section that reflects the 1917 origins of this road. It wasn't until 1933 that it could reach Big Bear Lake. It's called "Rim of the World Highway,"
it feels very much like that, particularly when the marine layer makes the valley disappear and you can only see the ridgeline, smell the sme
from wood-burning stoves, and at times catch a whiff of snow and pine bough.

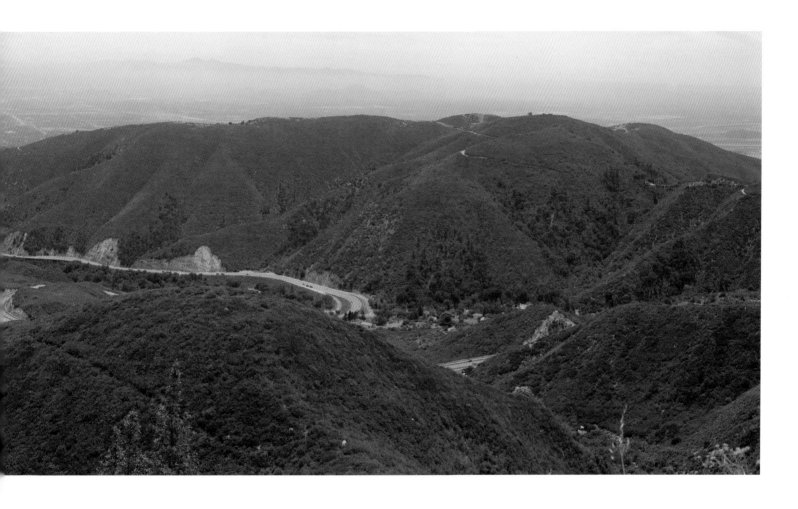

Highway 18, past Crestline turnoff, June 2013, 13 x 20 inches

Arrowhead, tour boat, June 2013, 13 x 20 inches

Lake Arrowhead, miniature golf, June 2013, 13 x 20 inches

e Arrowhead, go-karts, June 2013, 13 x 20 inches

20 x 91 inches
34° 13'43.92" N, 117° 13'47.95" W

Rim Forest, June 2013

Highway 18. Zen meditation. In the mid 1970s, I studied Buddhism at UC Riverside under the direction of Frank Cook in the religious stud[
department. Midweek found a group of us in his living room practicing zazen, sitting meditation. Frank assured me that meditation was av
able to anyone, anywhere. Driving was my meditation. As I let my mind become one with the machine, the quirks of an individual car would
revealed. My mind could picture all the component parts of the car, see the intricate operations, the interlocking functions. The aural feedb
of tires and engine sounds became my only reality. There are moments when the road rises and turns: all I can see is the sky and perhaps
distant valley below. A sudden exhalation as I realize I am airborne and will return to earth only after an eternity of falling. But there is the ro
where I hoped it would be.

 Rim Forest was a turnaround point where ascent became descent. During snowstorms, this little enclave was the point where chains w
required. I rarely tested my concentration against the snowflakes or the opaque cloud cover. Rim Forest is not the ersatz Swiss village that L
Arrowhead pretends to be. It is a practical point for car parts, lumber, and towing services, the staging area for dealing with mountain emerg
cies. Dump trucks, bulldozers, diesel generators, stump pullers, chopped wood. There are commercial vehicles that have failed the test, imm
bile trucks, flat tires, broken concrete and asphalt, casualties in the fight to keep mobile when the snows come. Look over this rim. On the va
floor is the moribund Norton Air Force Base, now the San Bernardino International Airport with a passenger terminal that has never been us

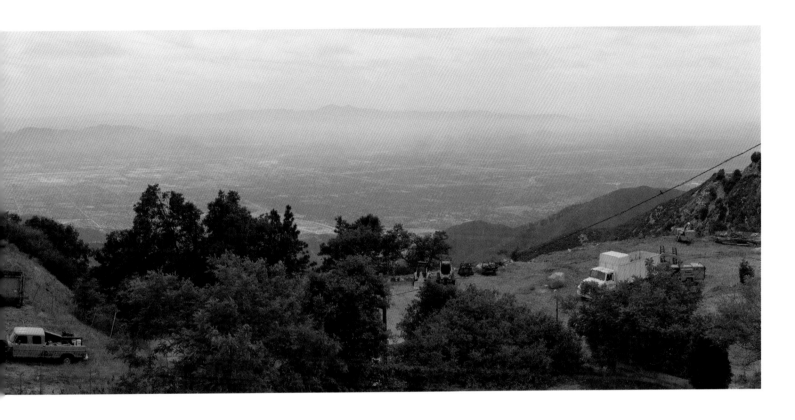

RIVERSIDE

Driving south on Riverside Avenue from Rialto there were times when a passerby could observe a deluge of muddy water sweeping down from the San Bernardino Mountains carrying trees, tires, and flotsam across the dip in the road. This would keep up for a few days after the rains, and my father would sometimes drive up to where the barriers blocked the road and we could gaze out at the sinuous mass that was the Santa Ana River. In my eyes, across the wild water was another world. It was where the barons of oranges had established their town.

The parent navel orange tree that created the second gold rush of navel oranges in late nineteenth-century California still stands at the oblique corner of Magnolia and Arlington Avenue in Riverside. There is a stone marker below it celebrating Eliza Tibbets's fortunate guest from Bahia, Brazil.

Between these two worlds was a divide between the rectilinear and the organic. Instead of the Army Corps of Engineers' heartless grid, which separated streets to baselines, meridians, and let-ters, the streets in Riverside followed the curves of the land, radiated like ripples around lilypad hills, the avenues flowing and colliding in arcs and tri-angles, like forces of a tectonic shift.

Riverside's Fairmount Park was designed by the firm Olmsted and Olmsted, famous for the layout of New York City's Central Park, among other great public spaces. As I child, I only knew the site was part of my play landscape on ceremonial Sundays after church. There was a World War I tank, a fossil-ized steam train, a green lake filled with crawdads and geese. A band shell stood largely empty, and a fiberglass kangaroo took our trash after picnics. Those afternoons in the park were some of the few times my mother seemed relaxed. The palms and pine trees protected the sandy playgrounds as my sister and I went from one recreational apparatus to another, self-enthralled in movement.

Some days we would have brunch at Riverside's Mission Inn, that wonder of a hotel that was not really a place so much as it was echoes of other places. Decades before Disneyland made imitat-ed reality a household concept, Frank Miller had

taken his father's Glenwood Hotel and created a wonder of simulation, where Spain, Italy, England, France, and Asian nations met in a comfortable riot of hospitality. It did seem like another world; where the character of my hometown, San Bernardino, was based on the American West, to me Riverside had the surreal sense of being farther away than it was. While downtown San Bernardino was presided over by the severe Doric columns of its courthouse, all somber gray granite, Riverside's festive French Beaux-Arts *petit palais* courthouse was a demonstration of excess and confidence. And of course the Mission Inn itself allowed one to move from an old English tavern into a French chapel, then encounter a secret Chinese inner courtyard all in a matter of minutes. Simulacrum becomes an authentic experience.

I returned to visit the hotel during the 1970s, in my college days, as the hotel was falling apart. It had become an artists' colony, and writers and painters paid monthly rent to live in its maze of idiosyncratic apartments. After many beers in the bar, one could sneak up the stairs and wander around the romantic corridors and narrow spiral staircases. In 1984, as I packed to move to Seattle, the Mission Inn shuttered its doors and the restoration began.

While San Bernardino had the majesty of its mountains to couch it in beauty, Riverside was left to dress itself, which it did in streets lined with regiments of palms and pepper trees, grand avenues, and richly appointed public buildings and homes. Julia Morgan designed the elegant YMCA building in the Italian revival style, which was echoed in subsequent downtown buildings. (Much to Frank Miller's chagrin, they had stepped out of his designated Spanish revival theme.) When I was young I was sometimes able to persuade my parents to drop me off in downtown Riverside, where I could go to the modernist Riverside Public Library and lose myself in the stacks. Afterward I would head to the Book Grotto, a musty downstairs room painted with murky murals and full of used paperback science fiction books. The Grotto had an archetypal feel, like descending into it was also descending into the collective unconsciousness of all creative minds.

Along the Arlington Heights corridor, my father sometimes drove us past an allée of palms, lines of rose bushes, and endless teaming orange groves. In later years, I would drive my serial supply of convertibles down Victoria Avenue at night and allow my head to swell with the sexual aroma of citrus blossoms.

There was a cultural gulf between my valley home and the Riverside environs as well. The Grotto and the library presaged the anticipation of my first trip onto the campus of the University of California, Riverside. I went there on a high school outing, and after setting foot on the small campus, I felt drunk, blissful. The next evening I drove back alone and started wandering among the buildings. The theatre was open, a graceful combination of concrete arches and modernist brick, say, Louis Kahn meets Frank Lloyd Wright, but more spare. I paid a few dollars and sat in the audience. Soon six musicians came out and started playing medieval instruments that captivated me. I felt that every note of that antique dissonance was speaking to me; I swore in that comfortable seat that I would come to this school and make it my home.

In the months that followed, I saw all manner of performances: plays, classical guitarists, voice recitals. In the most brilliant moment of all, I saw a culture of decadence and aversion for the first time; I was pulled into the world of John Waters and I witnessed *Female Trouble*. I heard the audience roar at each subversive, sardonic, and ugly inverted witticism.

As much as I wanted it, I did not get quite what I wished. I spent my first post–high school academic year at San Bernardino Valley College. I wanted to be an architect. Indeed, in 1972 I signed up for the first in a series of drafting courses and walked into a room full of drawing tables with attached Mutoh pantographs. The setting made sense, but the class wasn't at all what I expected. A large bald man was shouting out something incredible. He was casting himself back and forth across the room as he talked about the notion of Forms, the perfection of reality that lay beneath our own, the Greek philosopher Plato. Then, bit by bit, he introduced logic that broke down that shining plan of the nature of the world. He asked us questions I could barely understand. It seems that the drafting class had been cancelled and the philosophy course was given the wrong room number. I knew at that moment I wanted to study philosophy instead.

My first philosophy paper involved a grueling ordeal of study and memorization the likes of which I had never experienced in public school. I had to read each line of my texts over and over to discern their logical precedents, their *a priori* tenets, so that I might question and attack them with unerring order. In some ways that was my first great academic accomplishment.

I added religion to the courses that interested me, and a year later I was ready to pay my way onto the UC campus that was to become my home from 1973 through 1985. It was on this campus that I was married and divorced. I studied Nietzsche and the Zen philosopher Dōgen. I learned how to practice zazen meditation. I painted pictures plein air, and developed my first roll of film. I exhibited my first two solo shows there and worked many years as an assistant to disabled students. During my dark sojourns into depression and useless self-loathing, I would wander the campus at night, trying to discern meaning, to find an answer to the dark impulses that tried to crush me. I found solace in the smells of the place: pine, vinca, eucalyptus, jasmine. I wandered into impromptu music concerts, dance recitals, painters' studios, and photography darkrooms. I wondered if I could do any of those things.

Moments of deliverance were handed to me by a wandering fox or a white barn owl I was lucky to encounter behind the agricultural station, along the edge of the Box Springs Mountains. The wonder of their existence would challenge my sodden thought patterns and I would wake up again. I started taking photography courses, carrying a camera everywhere. The teachers in the photography program hired me to serve as a teaching assistant in the black-and-white labs. I started filling in all the technical knowledge that I might have missed or overlooked in my regular classes. I was given keys to the labs, and I spent long nights and mornings breathing the smell developer, fixer, and selenium toner.

Being on campus so much meant that I was sure to find buildings left accidentally unlocked, or maybe an access tunnel to some mechanical room or an attic of mysterious materials, ledgers, and scientific equipment.

It seemed easy to find ways into the older, lesser used buildings. The original agricultural station, fashioned in Spanish revival style, was an aerie I visited frequently. My musician friend and muse,

Chuck, would join me evenings with guitars and tape recorders in hand. We would find an echoey stairwell and improvise for hours. The reverberation would build and fold in on itself. It seemed like were not alone, like another spirit had entered us, and the hair would rise on our necks and we would steal out of there when we became too scared.

The culture of the university taught me that while societies were finite, limited to time and place, culture in itself was a different animal. Culture was infinite; Chinese poetry, punk music, postmodern structuralism, and dance parties were all infiltrated with the spirit of creation and interconnection. Everything was in play.

I wandered among the dry, grassy hills overlooking the university, often hearing the carillon musician play the bells in the clock tower. The giant boulders that captivated the low but steep slopes of the Box Spring Mountains at the eastern end of Riverside looked as if they were ready to roll down and crash into the subdivisions below. Beyond that were the botanical gardens and wild stands of cactus where auto raceways, freeways, and the roar of B-52 bombers laden with nuclear destruction entered and exited March Air Force Base. Farther west I saw the little

patch of water of Lake Matthews and the hazy air pollution heading east from Los Angeles. The air would turn orange as the sun became oblate. Sometimes the air was thick enough of a filter that a person could see sunspots on the surface of our star. Then the sky fell into a magenta sink of darkness. Crickets found one another in the night, and a few stars that could penetrate the haze winked into existence.

I came to live in Riverside in a moment of pique. My grandfather had died. I rented one of the many houses he owned in Colton, and the property was coming under the scrutiny of my mother's siblings. My uncle, drunk and loudmouthed, came to my door one evening. "Your days of ripping me off are over," he said and handed me a note. He had tripled my rent. In a couple of days I found another house to live in, managing the rent with a few friends. The house was in Riverside, an area west of campus where English nobility and Shakespeare had reign over the street names. Macbeth Place, Windsor Road, Sedgwick Avenue. I resided at 1953 Prince Albert Drive, a split-level house whose yard spilled down into a creek wash. There was no back fence, just a wild field. Beyond that was a farmhouse and an orange grove.

The owner's first name was LeBaron. He was a mathematics professor at the university, and when his wife had left him, he had moved to a condo near campus. He had no furniture, just sawhorses with door blanks filled with papers, books, and scribbled notepads. His former spouse was Wiccan and had planted the backyard to represent the garden at the beginning of humankind. Fig, pomegranate, citrus, and walnut trees were arranged in a pattern that narrated the story of Wiccan creation.

The house was a rambling four-bedroom with a large picture window that looked out over the garden mound of iris flowers. My partner and I lived on the east side of the house, my other roommates on the west side. It was like two homes with a common area for living room and kitchen. I learned to love that house; I fashioned a darkroom in the utility room, took photographs in the backyard, painted a 1964 Barracuda in the garage. We lived with the gentry of the Victoria Country Club just across the street, but had an eclectic and bohemian array of guests and short-term roommates.

Six years after I came to live in Riverside, and eleven years after I first enrolled at the university, I packed a moving truck and left for Seattle, for my first full-time job in the arts. For years memory of that backyard captivated me, the sojourns of possum in the moonlight as they foraged for scraps from the barbecue grill, the coven of skunks that wandered in looking for fallen fruit. I remembered our faithful dog, Ursula, who had simply appeared in the yard one day, starved and covered with burs. It was all gone, and for years afterward I dreamt of the figs and longed to smell the pepper trees again.

20 x 106 inches
34° 1'36.72" N, 117° 21'52.03" W

Riverside, January 2009

To reach the San Bernardino Valley from Riverside without the benefit of freeways, there is one main artery. Riverside Avenue runs from the b
of the Riverside Convention Center, passes north through Agua Mansa industrial corridor, through Rialto, and then makes an abrupt turn to
northwest, ending in Nealeys Corner in Fontana at the canyon mouth that is the main fork of Lytle Creek below the peak of Mt. Baldy. Wh
Riverside Avenue crosses the Santa Ana River there is a bridge that spans river willow and a miscellany of riparian opportunists that block
view of the normally weak rivulet of water searching for a path to the Pacific Ocean. On the north bank of the river at this intersection of road
riparian trails is a series of logistics centers. Logistics, a word that found its way out of military jargon, is an economical way of saying "giga
warehouses of millions of square feet that are staging grounds for goods, food, and imported products waiting to be sent to other distribut
centers that look much like this one, long bays of doors with mysterious spaces behind them." Eventually these things find their way onto tru
and into stores. This site was formerly the range of a number of thoroughbred training facilities. As one passed the corrals and tracks, horses
their trainers went through the gymkhana. One dark night in the early seventies, I was struck by a galloping horse that crossed Riverside Ave
into my path. All at once, I saw the primordial image of a horse rearing up, its eyes wide. Then the impact of the horse against the flank of
car, and in a moment I was facing the wrong way on the road. I got out of the car in a panic and touched the side of the car, slick with horse sw
and hair. The horse had disappeared. Magically, the car was undamaged.

Riverside, 6th Street, July 2012, 13 x 20 inches

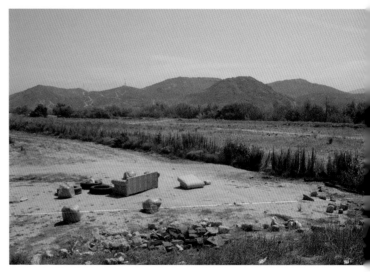

Riverside, Santa Ana River Wash off of Riverside Avenue, August 2012
13 x 20 inches

...erside, Washington Street, January 2013, 13 x 20 inches

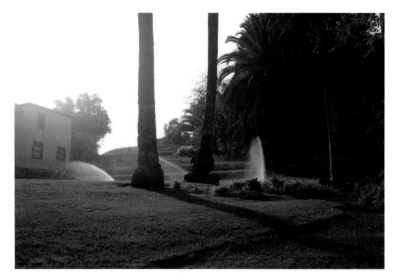

Riverside, Myrtle Avenue, January 2013, 12 x 20 inches

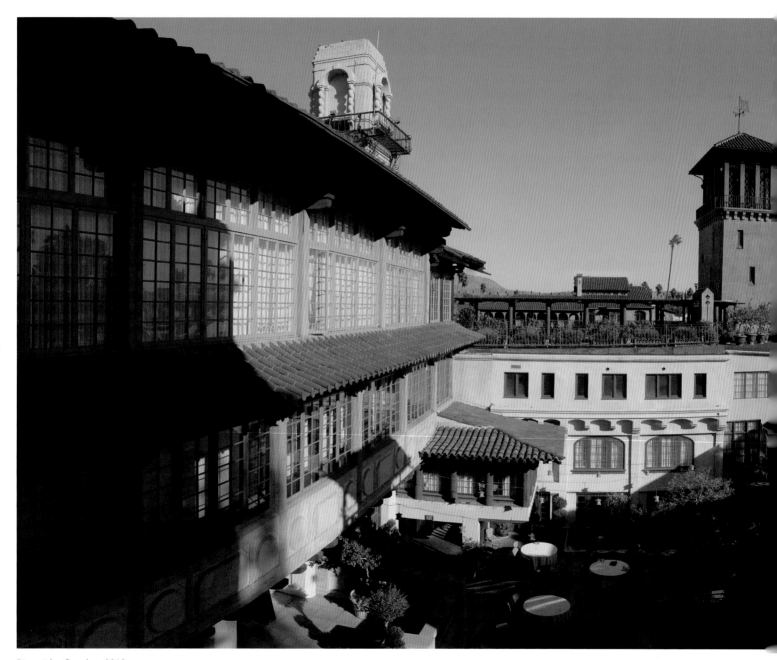

Riverside, October 2013

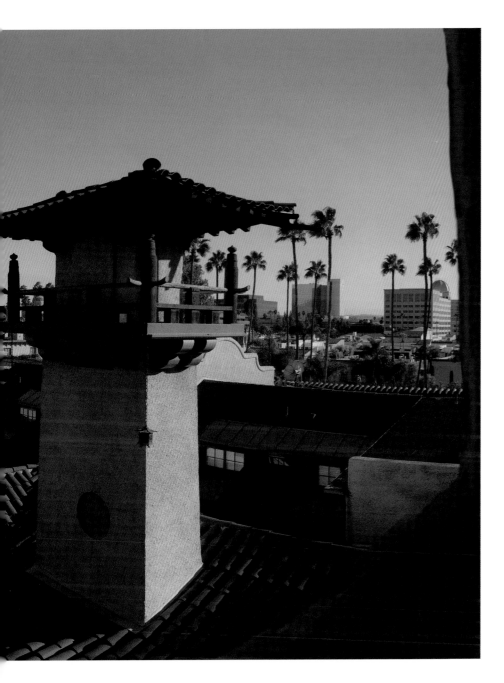

From 1902 to 1935 Frank Miller transformed his father's Glenwood Inn into the Mission Inn, an expansive city-block hotel that, like other idiosyncratic buildings of early California, offered its visitors endless hallways, doors, staircases, and surprises, all in Miller's favorite revival styles. When I left the state in 1984, the inn's popularity was coming to a close, and many spoke of razing it. By 1992 it was open again, and it is now the soul of downtown Riverside. I remember Easter brunches there when I was a child, and later, in college, the bar was filled with the cultural icons of Riverside—professors, philosophers, dancers, painters, writers, poets, and musicians. At one point the hotel had become a residence for bohemian types who made their homes in the odd, threadbare rooms or along the spiraling rotunda outfitted with lead-glazed windows and heavy oak furniture. I once witnessed the filming of an episode of *Quincy, M.E.*, with Jack Klugman running down the rotunda steps after an antagonist. When I came back to visit my hometown after I'd moved to San Francisco, I declined staying at my parents' house in San Bernardino and pretended to live in the Mission Inn. It has been my base for this entire series of photographs, and I revel at the variety of shapes, angles, and vistas this place provides. Though a representation of Europe and Asia, it has become a genuine place of echoes and memories of Riverside's energetic culture.

24 x 50 inches
33°59'0.62" N, 117°22'23.02" W

Top: Riverside, 12th Street, July 2012, 13 x 20 inches
Bottom: Riverside, CalTrans building, Spruce Street, July 2012, 13 x 20 inches

side, OSI Industries, July 2012, 13 x 20 inches

Riverside, October 2013

At the eastern end of the UC Riverside campus sit the Botanical Gardens, a magical transposition of many lands pressed into a forty-acre enclave. This photograph was taken from inside the gardens, atop one of the millions of granite boulders that protrude from the soft hills of the Box Springs Mountains. The particular boulder in question was the site of my amateur meditation practice, a bogus invention cobbled together from what I gleaned from Zen meditation and other religious traditions I studied while a student at this campus. Each time I came to this spot, some aspect of the place would assert itself: the lizards that came to visit me, the echoing of birdcalls from the trees to the gully below, sometimes the trickle of water that pushed out of the aquifer, and other times just the heat of the stone itself, or the Santa Ana winds pushing at the trees, the windblown conversations of people walking through the garden, the hot smell of eucalyptus.

20 x 78 inches
33°58'7.42" N, 117°19'10.14" W

20 x 150 inches
34°0'37.79" N, 117°25'9.94" W

Jurupa Valley, January 2015

I stand in 116-degree weather on the invisible (because it is underground) West Riverside Canal facing a neighborhood called Sunnyslope. The heat makes the far distance look like it is out of focus. To my right I see the two cliff faces that stand in partial shadow: two abandoned limestone mines. If I could see through the mountain, follow the same vein of limestone, I would see the big bump of a hill mixed with hundreds of unique minerals, all extracted at the Crestmore quarry, owned by the Riverside Cement Company. On the right stands a series of mine faces and pits, now surrounded by the Quarry Hills Country Club, whose golf course snakes through the rough-hewn mountains. Beyond the swale is Fontana and its medical-industrial complex of Kaiser Permanente Hospitals. If I could look down through the topsoil into the water table itself, I might detect the toxic chemicals that mixed with the groundwater and plume from the former Stringfellow quarry, now a Superfund cleanup site just a few miles west in Pyrite Canyon.

20 x 112 inches
33°54'7.64" N, 117°18'49.73" W

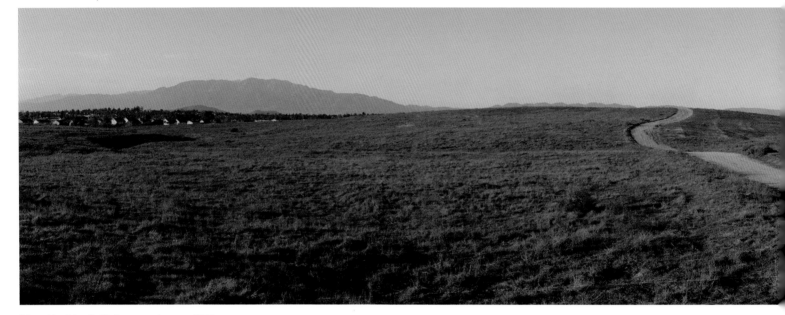

Riverside, March Air Reserve, January 2013

I think I am used to seeing invisibles—the past, the secrets, the hidden fear of nuclear destruction. I stand west of Moreno Valley's March Air Fo
Base, the former center of Strategic Air Command for the West Coast. The pounding low-frequency sound of equipped B-52 bombers still re
nates in the contaminated soil, the exposed rock and groundwater. The base no longer serves the SAC; it is a reserve base. There is a bit of bl
land here, beyond the edge of Riverside's suburban parade, watched over by resolute Mt. Baldy. Follow the line of the blue San Bernardinos a
see the Box Springs Mountains dotted with unlikely boulders, and to the right, in front of the San Gorgonio and San Jacinto peaks, are the g
leftovers from the trek to Armageddon: a neighborhood of sunken bunkers patrolled by white SUVs. You can walk your dog there, but only alc
the other side of the chain link and razor wire. It is a strange landscape of bumps of earth and the surprise of thick steel doors.

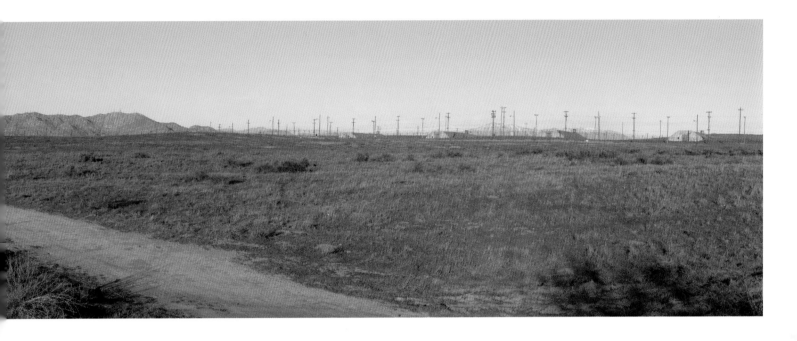

Riverside, southern field of the UC Riverside campus, July 2012, 13 x 20 inches

erside, Watkins Drive and Nisbet Way (former home of Joe Deal), January 2013, 13 x 20 inches

PALM SPRINGS
INDIO
THE SALTON SEA

The universe began in Palm Springs. Two unruly and competitive brothers, Mukat and Témayawet, had been hatched out of a fiery egg swinging in the void. They created the earth and its environs. They created creatures. Témayawet preferred beings with six or eight limbs, swiveling heads, compound eyes, and all manner of locomotion. Mukat was the economist; his had just two eyes, one head, hands that could form many shapes, legs that could be swift. The brothers argued as to which scheme was best. Then they argued about the invention of death. Témayawet wished for his beloved inventions to live forever. Mukat saw the folly in that; the world would fill up with his minions and all would collapse. Mukat introduced death, and Témayawet, in protest, went down the underworld, taking many of his radical creatures with him.

Mukat's people, the Iviatim, now known as the Cahuilla, were suspicious of Mukat's new game of death, so they gave his gift back and poisoned him. This patricide caused the Cahuilla people to wander in regret until they returned (some say) to the source of the world: Palm Springs, the beloved canyons with cool water and sheltering palms.

For my father, Palm Springs was a constant source of nostalgia. In my teenage years he started making drives from San Bernardino to Palm Springs, braving the wind and the paint-stripping sands of Highway 111 at Whitewater, along the way to his former village. He looked at the town and saw the ghosts of things. Replogle's store, the Agua Caliente Bathhouse, the Hotel del Tahquitz—places my grandmother served as a maid or general help. Sometimes we would drive up to the Palm Canyon reservation gate. Often my father would argue with the gatekeeper about who he was and who his family was, gunning for free admission; sometimes he would have to pay to wander his childhood home.

My father would point to a mound of melted adobe bricks and say that is where he lived. Where he and his mother and sisters would wait for my grandfather to stagger in late at night, drunk and angry. Where his mother would whack his father in the back of the head with

a frying pan so he could sleep it off and not terrorize the children.

I would see different things: the sleek, modern houses with their glass walls, bright blue pools, and carports with white Mercedes parked placidly inside of them. Palm Springs was a place to drive to get pancakes on a Sunday morning with my Riverside college friends and then wander in the neighborhoods looking at all manner of desert flower and foliage. With camera in hand, it was exciting to find interesting ruins of fifties-style houses, stores, motels, paint burned off by the sun, concrete bleached white and chalky. On the street, I thrilled at the cracked, crispy upholstery of cars parked outside too long, the paint turned into delicate powder, the vinyl tops peeling like desiccated scabs.

In the seventies my friend Mark lived for a time in the sandy expanse east of Palm Springs. The air conditioner was never off, and one side of the morning newspaper was always yellow after a short morning blast of 100-degree sun. Across the street was an open field of sand dunes and creosote. People would drop their old televisions, couches, and broken barbecues there. We took to pitching rocks into the picture tubes.

In the winter, it was difficult to get around. The town filled with tourists, "snowbirds" from the East and Midwest, looking alien in their golf shirts and sundresses, glaring white shoes. The malls were jammed with people buying upscale fashions and downscale "Indian" jewelry. Further on, there were enclaves of expensive auto dealerships, luxury carpet stores, and what I derided as ersatz art galleries. What hung through the air beyond the sting of light was the endless growl of lawnmowers and the singing tingle of water sprinklers that kept the golf courses green and the nonnative plants in flower.

Curiosity drove me east, leading me to find another ghost, the accidental and incomplete shadow of ancient Lake Cahuilla. This false reflection was formed in 1909 by a series of mishaps: floods, broken dams, and blocked canals that poured water into the old lake basin, that birthed the Salton Sea. This sea is the perfect setting for

future ruins, blank cities and resorts that never quite come to life. Algae blooms sometimes rear up, the oxygen gone out of the water and the salt content high; millions of tilapia expire on its numerous shores, one eye up, looking into the sovereign star. Water birds by the thousands find this silent shore and crowd it with their squawks and shrieks.

For a photography project, I decided that I wanted to see the sun rise over the sea; what a dream to see the dawn over the water. In 1987 I picked up my father in my little red Acura coupe and we went out in the early morning to wait for the light to break on the banks of the sea at Thermal. As my tripod and trusty Mamiya camera caught the first rays of morning, behind me untold acres of date palms welcomed the heat. After that, we drove into Indio for pancakes and coffee.

I returned to this sea many times. Coming back from afternoons near the briny stillness, I chose the old highway route, rather than I-10, preferring to pass through Indio, Palm Desert, Indian Wells. (An actual Indian well was a diagonal ramp dug into the earth until it hit water, a kind of walk-in swimming pool.)

As my drives accumulated, the haze of past, present, and future would attack my sense of where in time I actually was. The desert feels more ancient and primal than the lands near the coast; there, all the efforts of humanity feel like a thin crust applied on the surface.

If I had enough burning light and dehydrating air, I would turn west and pursue the blessed shadow, the "magic time" when the San Jacinto Mountains threw themselves in front of the sun. When the umbra falls across Palm Springs, there is a welcome sigh. The sunglasses go back in the pockets as the hot blanket of twilight covers the houses and golf courses, the glittering, clattering palms, and the mysterious smoke trees.

I can anticipate a warm night and the kind of strange freedom that takes over. Convertible tops go down, moon roofs slide back, and windows open. Broken glass bottles strewn along the highway sparkle in the headlights. Landscaping lights, invented for this desert night, illuminate palms and send articulate shadows across the straight planes of the walls sectioning off the gated enclaves of the city.

Looking west against the failing twilight I see two big peaks, San Jacinto and Tahquitz. I find

it an interesting pairing. San Jacinto, or St. Hyacinth, was an early second-century Christian martyr. He is paired with the Indian demigod Tahquitz, a voracious eternal spirit brought forth by Mukat and Témayawet who still captures the hapless souls wandering the mountain, consuming their energy, leaving them to illness and death. I turn away from these ancient symbols of Catholic and native lore. There are more contemporary concerns.

The Cahuilla sued the US government in the 1970s after the feds raided their hot spring spas, which included newly installed slot machines. In 1981, the government relented, and so began the great launch of public Indian gaming. Those "dirty Indians," who had been deeded in reservation land every other square block of Palm Springs, started to see money and influence swirling around them, and they wanted a piece of it. More casinos appeared, from Morongo to Soboba. The nouveau riche of indigenous peoples formed tribal governments and bureaucracies, invested in scholarly research, museums, infrastructure. "Buy America Back" was my motto. But that is not to say all money was a good influence; human greed and accumulation of wealth did not

mix well with the psychology of decades of genocidal acts. A kind of cultural and spiritual trauma persists. Many of my cousins, aunts, and uncles met violent deaths, or their internal organs failed after years of using alcohol. I don't know whether the ID number I was given by the federal Bureau of Indian Affairs—16350—is a badge of honorable blood or a mark of future extinction.

When I drive back to Riverside through the pass, pushing against the wind, I sense that I am leaving a home I never had. Ahead on the right is Whitewater, where thousands of majestic spinning blades create power. The Cahuilla say that all is power, a'iva'. But our kind of power is not the kind that creates order. Our kind of power is intrinsically unstable; it is the chaos out of which comes life, novelty, and invention. In Cahuilla cosmology, the concept of stasis or balance is not only impossible but undesirable.

Farther west, I look past the Morongo reservation casino and remember the day when my father and I drove to the Malki Museum in Banning so I could pick up some books. He squinted at the pictures in the museum display. There were some familiar faces, he said. After we left, my father wanted to drive north on the dirt roads,

to look for the old chapel school building at the base of the San Gorgonio foothills. We found the site, but the building was gone. He told me how angry and grim the Catholic sisters had been.

I asked him why he did not return to the reservation. "You don't realize. Indians were treated as subhuman," he said. "I wanted to be free. Not an Indian, just a man." In America during the forties and fifties, being a man meant having your own home, working for yourself and supporting your family, discarding notions of traditions. It also meant suppressing your memories for as long as you could. It meant reciting that your grandfather, Terbosio De Soto, actually came from southwest Spain. It meant obscuring the story of how he came to southwestern North America and married a native woman.

Now I cruise into the valleys below San Gorgonio Pass and see the hint of Los Angeles in the western glow of muggy ocean air. I remember how chaos reinvents everything. How it reinvents even people, from the first humans who wondered what the ravens told the spirits, to the Spanish who "missionized" (with disease, slavery, rape, and torture) the indigenous locals, to the Americans who came afterward, filled with lust for gold. It was the Americans who established quotas for native scalps and brought our people to the brink again. The Americans established the agriculture of order and plentitude, of their kind of "power." But still I see the workings of *a'iva'* all around. Chaos parches the orange groves. Fast-food architecture clusters like cancer at the junctions of freeways. Walmart parking lots are dotted with homeless people living in their cars. Stucco houses are patched with iron grates on doors and windows to keep out poachers. The palm trees, *Washingtonia filifera*, here in the beginning, still watch it all.

Springs, South Caliente Drive, June 2013, 13 x 20 inches

20 x 77 inches
33°43'57.83" N, 116°32'8.43" W

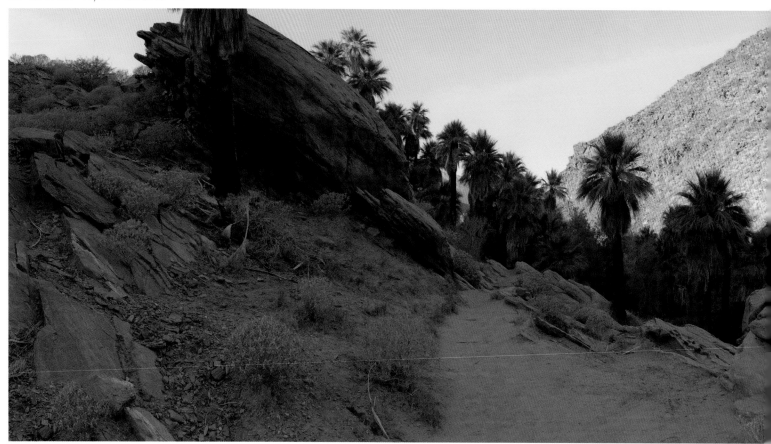

Palm Springs, January 2014

My father grew up at the mouth of Palm Canyon near the cooling pools of water in Murray Canyon. Now the area is a reservation park, and
little adobe house he lived in with his father, mother, and sister has long turned to dust. He told me that the canyon was the heart of who he v
The last time we went for a walk there he was beaten down by cancer in his leg and he made his way slowly, with a cane, down the steep hills
into the narrow V of the canyon. I made a videotape of him standing at this point. He wore light blue pants and a white shirt. He stood sile
and looked down the canyon wall. We could hear water moving in the creek bed.

As the sun drops behind the San Jacintos, a long, open shadow begins marching across the desert. This is the "magic time," as he called
when the searing heat eased off our skin and we could look east from the shadow into the light as the silhouette of the mountains crossed fr
Palm Springs, Cathedral City, Rancho Mirage, Palm Desert, Indian Wells, into Indio.

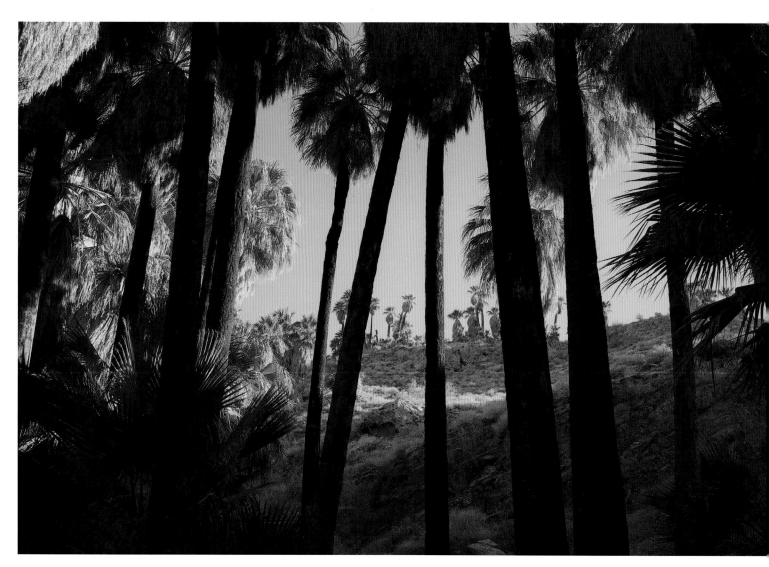

Palm Springs, Palm Canyon, January 2013, 13 x 20 inches

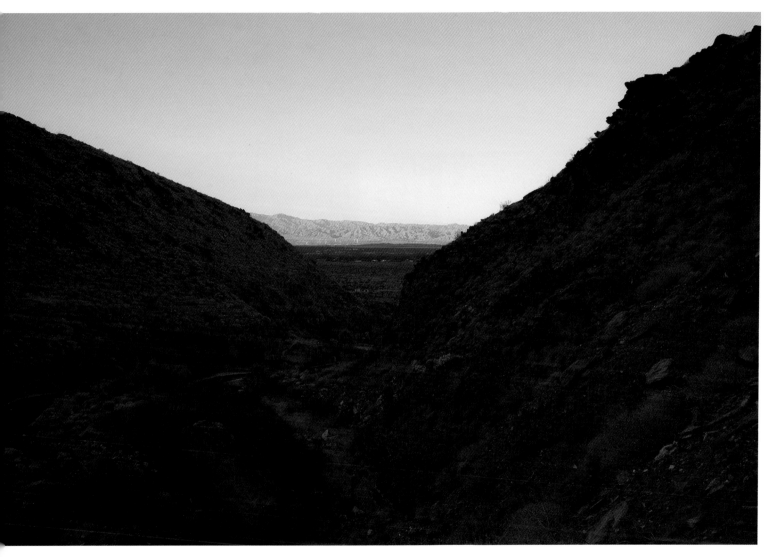

Springs, Palm Canyon looking north toward I-10, January 2013, 13 x 20 inches

Palm Springs, East Alejo Road, June 2013, 13 x 20 inches

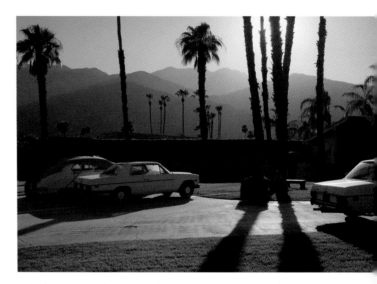

Palm Springs, South La Verne Way, June 2013, 13 x 20 inches

m Springs, South La Verne Way, June 2013, 13 x 20 inches

Palm Springs, South Caliente Drive, June 2013, 13 x 20 inches

Top: Salton Sea Beach, Coachella Avenue, January 2014, 13 x 20 inches
Bottom: Thermal, off Highway 86, January 2014, 13 x 20 inches

mbay Beach, January 2014, 13 x 20 inches

20 x 160 inches
33° 22' 44.45" N, 116° 0' 29.61" W

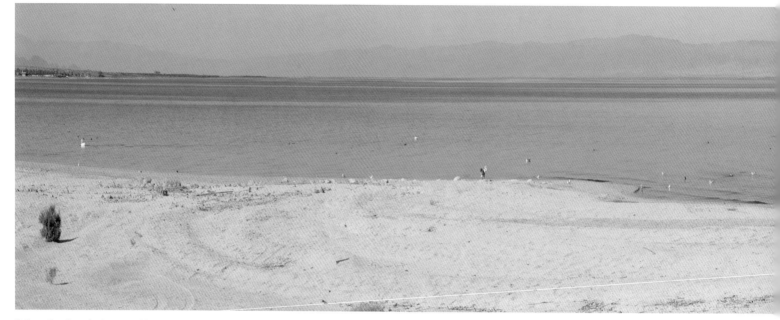

Salton Sea Beach, January 2014

The Salton Sea is the largest lake in California, about 345 miles of surface that constantly change due to drought and flood conditions. Creat
by a mistake of hydraulic engineering, it is the result of the Salton Basin being accidentally filled with water from the Colorado River over a peri
of years at the turn of the twentieth century. In 1905, heavy snowmelt and rain overwhelmed the canals built to divert water into the arid desert
farming, and at one point there was a magnificent eighty-foot waterfall cascading into the sink. The Torres-Martinez Reservation was underwa
and it took two years for the canals to be repaired.

With the flooding stopped, the sea maintained itself as a saline eye in the desert, and it became the site of several resorts, most of wh
failed as quickly as they were formed. Among these lakeside enclaves is Desert Shores, which persists as a small community of a thousand
so residents. The sand there is made of the crushed shells of ancient Lake Cahuilla, and in the desert hills to the north and east across the la
one can still find fossils and the remains of coral. Millions of seabirds feed at the lake, and they nest and die along its edges. Fish perish by
billions when the waters become too saline for life and the algae blooms obliterate oxygen from the water. This place is a living mirage but a
an accident, and it comes with a lesson. It serves as both a mirror of and a warning about the cycles of creation and destruction, both along
shores of a desert lake and inside the minds of men.

) x 139 inches
3°54'28.60" N, 116°39'10.11" W

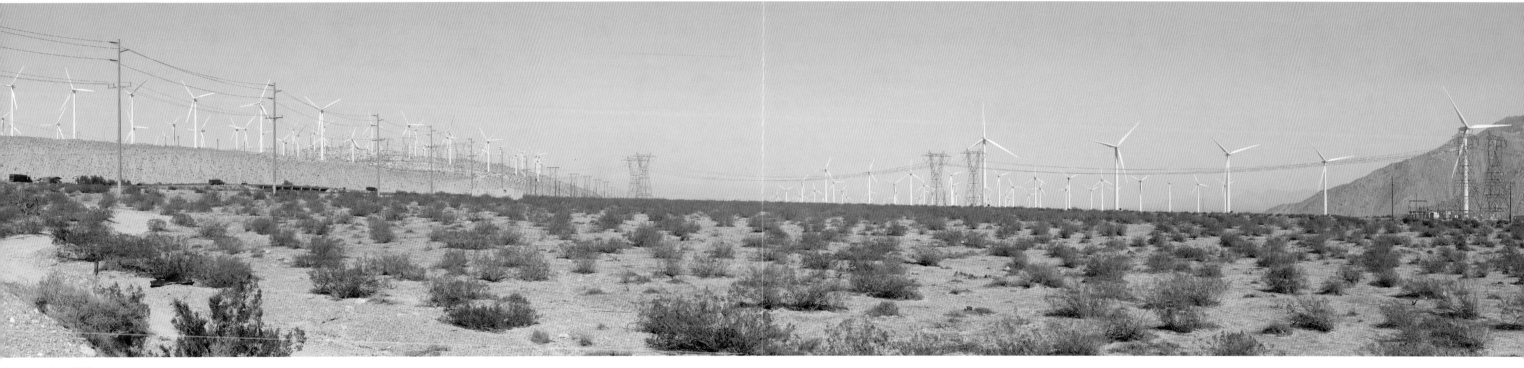

hitewater, June 2013

ere are over a dozen distinct wind-energy firms that operate in the San Gorgonio Pass Wind Farm. The set pictured here is aligned with
e opening of Whitewater Canyon, directly to my left (north). When my father used to drive us from San Bernardino to Palm Springs, this
ea was known mostly for its blowing sand, and he was paranoid enough about damage to his car that he would often double wax it in
pe that the fine granules wouldn't find purchase in his paint or glass. Now this wind yields almost one terawatt of energy as it creates a
arkling visage of white turbine blades nearly impossible to catch in still photographs.

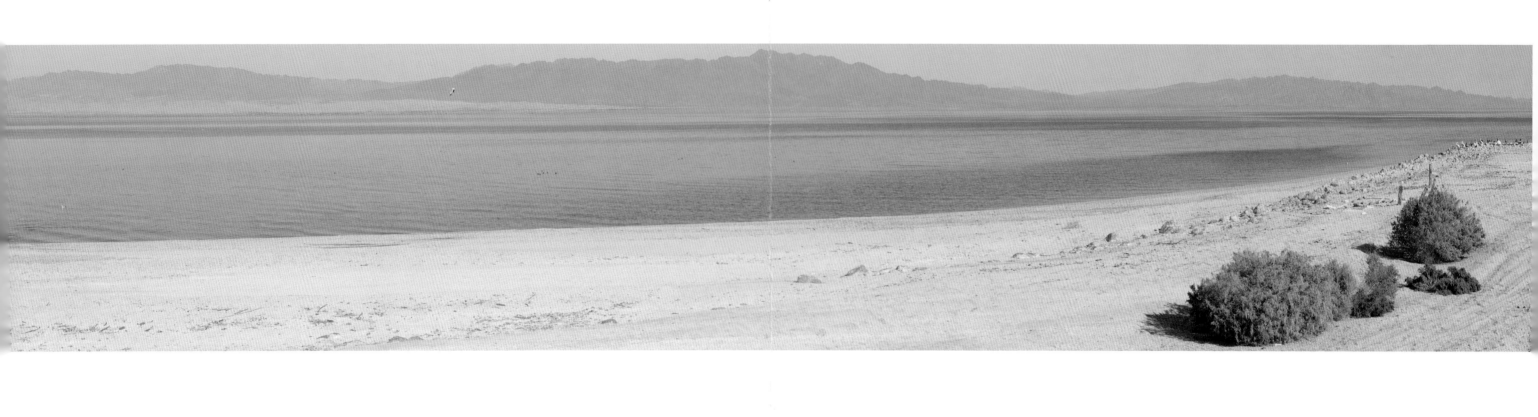

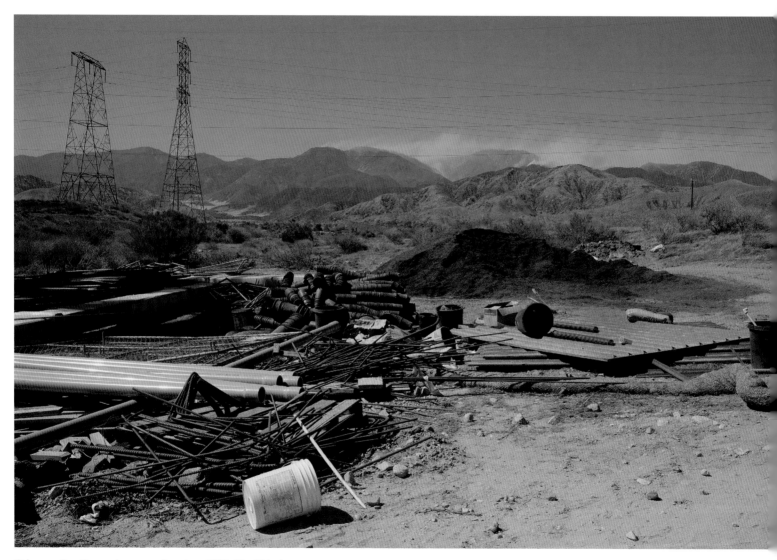

Cabezon, San Gorgonio canyon fire, June 2013, 13 x 20 inches

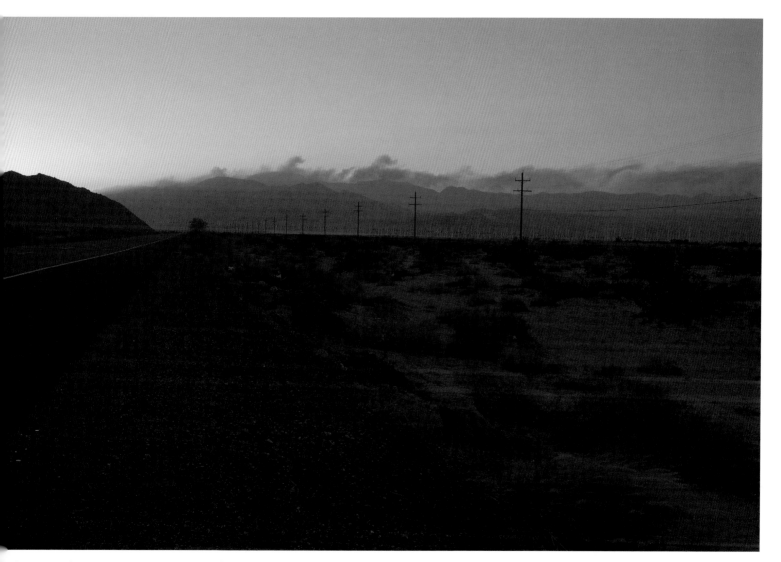

Springs, Highway 111, San Gorgonio canyon fire, June 2013, 13 x 20 inches

ABOUT THE AUTHORS

Lewis deSoto, an artist of Hispanic and Cahuilla ancestry, was born in San Bernardino and grew up in Southern California's Inland Empire. DeSoto's photography, sculpture, and visual and sound installations have been exhibited widely across the United States as well as in England, Italy, Mexico, Portugal, Spain, Japan, and Sweden. His work is included in major museum, corporate, and private collections, including those of the Atlantic Richfield Company (ARCO); the Bank of America; the California Museum of Photography at UC Riverside; the Center for Creative Photography in Tuscon; the Columbus Museum of Art; the Des Moines Art Center; the Los Angeles Center for Photographic Studies; the Los Angeles County Museum of Art (LACMA); the Museum of Contemporary Art, Los Angeles (MOCA); the Long Beach Museum of Art; the Museum of Modern Art in New York (MoMA); the Museum of Contemporary Art San Diego; the Museum of Photographic Arts in San Diego; the Nelson-Atkins Museum of Art in Kansas City; the Orange County Museum of Art in Newport Beach; the San Jose Museum of Art; the Seattle Art Museum; the Serralves Foundation in Porto, Portugal; and the Berkeley Art Museum. DeSoto holds a master of fine arts degree from Claremont Graduate University and is a professor of art at San Francisco State University.

Paul Chaat Smith is the author of *Like a Hurricane: The Indian Movement from Alcatraz to Wounded Knee* (with coauthor Robert Allen Warrior) and *Everything You Know about Indians Is Wrong.* Smith is a member of the Comanche Tribe of Oklahoma. He joined the Smithsonian's National Museum of the American Indian in 2001, where he serves as associate curator.

Sant Khalsa is an artist and curator whose projects develop from her inquiry into the nature of place and critical environmental and societal issues in the American West. Her artworks are widely exhibited, collected, and published internationally. She is a professor of art emerita at California State University, San Bernardino.

ABOUT THE INLANDIA INSTITUTE

The Inlandia Institute is a lively center of literary activity located in Riverside, California. It grew out of the highly acclaimed anthology *Inlandia: A Literary Journey through California's Inland Empire,* published by Heyday Books in 2006.

The Inlandia Institute strives to nurture the rich and ongoing literary traditions of inland Southern California. Its mission is to recognize, support, and expand literary activity in the Inland Empire by publishing books and sponsoring programs that deepen people's awareness, understanding, and appreciation of this unique, complex, and creatively vibrant area.

For more information about Inlandia Institute titles and programs please visit www.heydaybooks.com/book_category/inlandia or www.inlandiainstitute.net.

ABOUT THE ROBERT AND FRANCES FULLERTON MUSEUM OF ART

CAL STATE SAN BERNARDINO

The Robert and Frances Fullerton Museum of Art at California State University, San Bernardino (RAFFMA) is dedicated to creating relevant and meaningful cultural experiences for the widest array of audiences, regional and beyond. RAFFMA provides art exhibitions and educational programs that illuminate, engage and inspire, enrich and transform lives.

RAFFMA opened its doors to the public in the fall of 1996, and since then it has grown to be one of the major cultural centers in the region. The museum hosts exhibitions of ancient and contemporary art from all over the world enhanced by a compelling array of educational programs. While contemporary art makes the majority of RAFFMA's programmatic offerings, the museum is best known for its ancient Egyptian collection—one of the largest permanent displays of Egyptian antiquities in the western United States, encompassing four millennia of Egypt's ancient history.

In 2008, RAFFMA was granted accreditation from the American Alliance of Museums, the highest national recognition an American museum can achieve, acknowledging the museum's continuing commitment to excellence.

For more information, please visit raffma.csusb.edu.

ABOUT HEYDAY

HEYDAY
to California

Heyday is an independent, nonprofit publisher and unique cultural institution. We promote widespread awareness and celebration of California's many cultures, landscapes, and boundary-breaking ideas. Through our well-crafted books, public events, and innovative outreach programs we are building a vibrant community of readers, writers, and thinkers.

THANK YOU

It takes the collective effort of many to create a thriving literary culture. We are thankful to all the thoughtful people we have the privilege to engage with. Cheers to our writers, artists, editors, storytellers, designers, printers, bookstores, critics, cultural organizations, readers, and book lovers everywhere!

We are especially grateful for the generous funding we've received for our publications and programs during the past year from foundations and hundreds of individual donors. Major supporters include:

Advocates for Indigenous California Language Survival; Anonymous (3); Arkay Foundation; Judith and Phillip Auth; Judy Avery; Carol Baird and Alan Harper; Paul Bancroft III; The Bancroft Library; Richard and Rickie Ann Baum; BayTree Fund; S. D. Bechtel, Jr. Foundation; Jean and Fred Berensmeier; Joan Berman; Barbara Boucke; Beatrice Bowles, in memory of Susan S. Lake; John Briscoe; David Brower Center; Helen Cagampang; California Historical Society; California Rice Commission; California State Parks Foundation; California Wildlife Foundation/California Oak Foundation; Joanne Campbell; The Campbell Foundation; Candelaria Fund; James and Margaret Chapin; Graham Chisholm; The Christensen Fund; Jon Christensen; Cynthia Clarke; Community Futures Collective; Lawrence Crooks; Lauren and Alan Dachs; Nik Dehejia; Topher Delaney; Chris Desser and Kirk Marckwald; Lokelani Devone; Frances Dinkelspiel and Gary Wayne; Doune Trust; The Durfee Foundation; Megan Fletcher and J.K.

Dineen; Michael Eaton and Charity Kenyon; Richard and Gretchen Evans; Friends of the Roseville Library; Furthur Foundation; The Wallace Alexander Gerbode Foundation; Patrick Golden; Erica and Barry Goode; Wanda Lee Graves and Stephen Duscha; The Walter and Elise Haas Fund; Coke and James Hallowell; Theresa Harlan and Ken Tiger; Cindy Heitzman; Carla Hills; Leanne Hinton and Gary Scott; Sandra and Charles Hobson; Nettie Hoge; Claudia Jurmain; Kalliopeia Foundation; Judith Lowry and Brad Croul; Marty and Pamela Krasney; Robert and Karen Kustel; Guy Lampard and Suzanne Badenhoop; Thomas Lockard and Alix Marduel; Thomas J. Long Foundation; Bryce Lundberg; Sam and Alfreda Maloof Foundation for Arts & Crafts; Michael McCone; Nion McEvoy and Leslie Berriman; Moore Family Foundation; Michael J. Moratto, in memory of Major J. Moratto; Stewart R. Mott Foundation; Karen and Thomas Mulvaney; Richard Nagler; National Wildlife Federation; Native Arts and Cultures Foundation; The Nature Conservancy; Nightingale Family Foundation; Steven Nightingale and Lucy Blake; Northern California Water Association; Panta Rhea Foundation; Pease Family Fund; Jean Pokorny; Jeannene Przyblyski; Steven Rasmussen and Felicia Woytak; Susan Raynes; Restore Hetch Hetchy; Robin Ridder; Spreck and Isabella Rosekrans; Alan Rosenus; The San Francisco Foundation; Toby and Sheila Schwartzburg; Stephen M. Silberstein Foundation; Ernest and June Siva, in honor of the Dorothy Ramon Learning Center; William Somerville; Carla Soracco; John and Beverly Stauffer Foundation; Radha Stern, in honor of Malcolm Margolin and Diane Lee; Liz Sutherland; Roselyne Chroman Swig; TomKat Charitable Trust; Jerry Tome and Martha Wyckoff; Thendara Foundation; Sonia Torres; Michael and Shirley Traynor; The Roger J. and Madeleine Traynor Foundation; Lisa Van Cleef and Mark Gunson; Stevens Van Strum; Patricia Wakida; Marion Weber; Sylvia Wen; John Wiley & Sons, Inc.; Peter Booth Wiley and Valerie Barth; Bobby Winston; Dean Witter Foundation; Yocha Dehe Wintun Nation; and Yosemite Conservancy.

BOARD OF DIRECTORS

GETTING INVOLVED

To learn more about our publications, events and other ways you can participate, please visit www.heydaybooks.com.